Nikon
F-801s

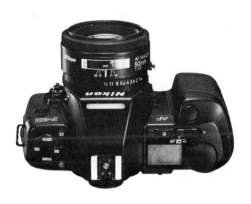

NIKON N8008s in U.S.A.

Michael Huber

D1364987

)KS

In U.S.A.

the Nikon F-801s is known as the

NIKON N8008s

All text, illustrations and data apply to cameras with either name

Nikon F-801s

First English Edition March 1989
Reprinted October 1989
Second English Edition October 1991
English Translation: Liselotte Sperl
Series Editor: Dennis Laney
Technical Editor: George Wakefield
Editor: Georgina Fuller
Typeset by Brighton Typesetting, Sussex
Printed in Great Britain by
The Bath Press, Avon

ISBN 0-906447-57-7

Published by
HOVE FOUNTAIN BOOKS
the joint imprint of

Fountain Press Ltd & Hove Foto Books
Queensborough House 34 Church Road, Hove
Claremont Road, Surbiton Sussex BN3 2GJ
Surrey KT6 4QU

Contents

Classic in Hi-Tech

Nikon is one of the first names that comes to mind when the word photography is mentioned. It started with the now legendary F-series (from 1962) and continued with the F-2 series (from 1972). Nikon soon set the standards for photo-reportage worldwide. To a large extent this was due to the fact that Nikon managed to develop high quality lenses for their camera systems, that were in no way inferior to the classic brand names of Zeiss and Leitz.

The electronically advanced F-3 (1980) could win a lot of friends amongst professional photographers. Amateur photographers, on the other hand, were very well served by the FA series cameras (1983) and also the FG models (from 1982).

Among modern Nikon SLR cameras, the F-301 in 1985, was the first with an integrated motor and is still very popular because of its many excellent qualities. Nikon's first AF SLR camera was the F-501 (1986). This model has a special appeal to the enthusiast for classical photography who wishes to avail himself of modern autofocus technology. Then followed the fully electronic F-401 (1987) offering very easy handling for the less experienced SLR amateur photographer.

The introduction of the F-801 represents another successful development by the Nikon engineers. This camera combines the latest technical developments in microprocessor-controlled AF camera technology with the requirements of conventional professional photography. Instead of gimmicky technical embellishments Nikon have applied the following principles:

○ Operating elements that are easily accessable;
○ settings lockable against accidental adjustment;
○ high-eyepoint viewfinder which is comfortable for sports photographers and people wearing glasses;
○ clear display of all important values and functions, such as shutter speed, aperture, and exposure compensation;
○ foolproof display of film transport, forward and backward;
○ extremely economical use of batteries, of a type easily and cheaply available worldwide;
○ compatible with older non-AF lenses.

Then there are such typical high-tech features as a top shutter speed of an incredible $\frac{1}{8000}$ sec., flash synchronization time of

$\frac{1}{250}$ sec., motorized film transport with up to 3.3 frames per second, super-sensitive autofocus functioning down to EV −1, four AF shooting modes, clever multi-field metering system, free choice between program, shutter speed priority, aperture priority and manual exposure modes, program shift, exposure lock, automatic and manual exposure compensation from −5 to +5 EV in ⅓ steps, manual exposure setting, several flash modes including automatically controlled fill-in flash.

This book has been written not only to explain the technical facilities of the F-801, but also how these may be used to obtain better pictures. This book has been arranged so that at the beginning of each main section the most important information for handling the camera is to be found (i.e. 'what button do I have to press ...?'). Then follows a description of what subjects and shooting situations are particularly well-suited to a particular shooting mode or if it would be advisable to change to another mode. The last sub-chapters are always dedicated to more detailed technical information. I have also included some general photographic topics, such as "basic principles of exposure" and "flash photography", which should be of interest to the more ambitious photographer who does not always want to rely on automatic functions. All that remains now is to wish you good luck and have fun!

Nikon N8008s/F-801s

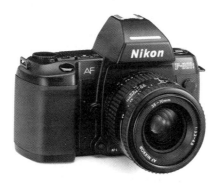

With the introduction of the N8008s/F-801s, Nikon have made an already versatile camera into an extremely versatile one. The most important new feature is Spot Metering; invaluable for any photographer who wants to have maximum control over exposure. The other useful feature to be introduced is Focus Tracking, which enables the camera to predict the movement of a subject and adjust the autofocus accordingly.

Spot Metering

The N8008 already offered matrix and centre-weighted metering, now with the N8008s Spot Metering has been added. In Spot Metering mode the metered area is a circle approximately 3.5mm diameter in the centre of the viewfinder. This represents just over

The area metered is represented by the approx. 3.5mm-diameter circle in the centre of the viewfinder.

1.1% of the total image area and makes it one of the smallest spot metering areas available on any similar camera, and therefore one of the most precise for selecting important parts of the image to meter. It is used when precise measurement of the exposure for a particular portion of the subject is required.

Spot metering enables the user to tackle those very difficult subjects when matrix and centre-weighted metering are unsatisfactory. It enables you to meter a very small area of the subject, or to take several measurements from different points in the subject in order to make contrast measurements, or to compare various parts of the subject. For example, subjects in strong side-light tend to be high in contrast and the reproduction capabilities of the film will probably be exceeded. With spot metering you meter the subject detail where the light and shade are balanced and this will generally give you a correct result. Back-lighting is another situation where spot metering is the only feasible method. Back-lighting requires very careful compromise as far as exposure is concerned. The main subject is in shadow and an average value for exposure would be inappropriate, you want details to appear in the main subject but at the same time for it to be maintained darker in order to give the impression of being in shadow. With spot metering, meter directly on the subject details in the shadow and then give the exposure a slight minus compensation. Another application for spot metering would be in portraits or groups where you can meter precisely on the flesh tones.

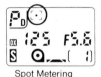

Spot Metering

The Spot Metering symbol in the LCD panel.

Spot metering is set on the camera in the same way as the other metering modes. Slide the main switch to ON and while pressing the metering system button, rotate the command dial until the spot metering symbol appears in the LCD panel. This is a small spot in the centre of a rectangular outline. To carry out spot metering, aim the 3.5mm reference circle in the viewfinder on that portion of the image which you wish to meter and then use the auto exposure lock facility to reframe the picture. If working in manual mode you can take any number of readings on various parts of the image and note the

exposure readout, then make your final selection using your own judgement after you have weighed-up all the data.

Note: Spot metering cannot be performed on the N8008s with the Type J focusing screen fitted.

High-speed Autofocus with Focus Tracking

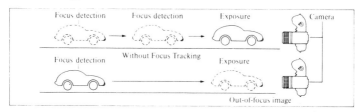

This schematic drawing illustrates the principle of Focus Tracking which enables the system to produce in-focus photographs in moving subjects.

This function is automatically activated when the focus mode is set to Continuous Servo Autofocus (**C**), the film advance mode to Continuous Low (**CL**), and the automatic rangefinder registers a subject moving away from, or towards, the camera at an even pace. The camera's computer analyses the speed of the moving subject according the focus detection data and drives the autofocus mechanism of the lens to the position that will ensure correct focus at the precise moment the mirror is already up and the shutter is released.

To select Focus Tracking set focus mode selector to C, and film advance mode to CL.

When the subject is in focus the in-focus indicator will light up in the normal way. *Note*: This is contrary to earlier editions of the Instruction Manual which state that the in-focus indicator does NOT light up and that you should release the shutter when the two triangular LED's in the viewfinder light up at the same time.

The Nikon N8008s will also recognise when the subject's movement becomes erratic and will automatically revert to the normal Continuous Servo autofocus mode.

To ensure correct operation of this function the subject must be kept inside the focus brackets in the viewfinder.

Two New Nikon Lenses

AF DC-Nikkor 135mm,f/2

This is a new specialist lens which enables the photographer to defocus the background or the foreground to emphasise the main subject. It is likely to find application in fashion, portraits, advertising, etc. The extent of defocus can be controlled by the DC-ring at the front of the lens without affecting the depth of field or the sharp definition of the main subject. It is NOT a soft-focus lens. It's purpose is to achieve isolation of the subject, as one does with a very long focus lens or with a wide aperture, but using a more practical focal length and with the ability to stop down partway to minimise aberrations.

You turn the DC-ring in the **F** direction for foreground control or in the **R** direction for background control. In either direction the ring is calibrated in stops from f/2 to f/5.6, the greatest effect being at the f/5.6 setting. The index selected on the DC-ring must NOT be less than the aperture set, e.g., if "f/5.6" index is set on the DC-ring, then the lens aperture must be bigger, i.e., between f/4 and f/2.

AF Nikkor 28-70mm,f/3.5-4.5

This is the first fruit of a new Nikon technique for producing aspheric elements, leading to lighter weight and shorter length zoom lenses at lower prices than have been possible hitherto with aspheric elements. It's focal length range makes it a very useful general purpose lens, especially for tourists.

Introducing The F-801

Using The Camera

It is important to be able to handle all the camera's functions without hesitation. Let's look at the camera and its operating elements in detail. I would recommend that you try out the functions described below as they are explained.

A General Overview: First we look at the F-801 from the front, with the lens removed. Top: On the left-hand side, at the top of the handgrip, is a rectangular red LED; this is the self-timer indicator. On the same side, by the lens bayonet mount, is the depth-of-field preview button. Pressing this button will stop down the aperture to the working value. Beneath that is the AFL (Autofocus Lock) button. Pressing this button will store the last-metered AF setting and retain that value as long as the button is kept pressed. Above the lens bayonet mount, on the viewfinder prism, is an illumination window for the LCD in the viewfinder. On the right-hand side of the lens bayonet mount is a white dot; this marks the point for correct alignment when fitting a lens. Next to that is a screw-cap protecting the remote control terminal. Further down, next to the lens bayonet mount, is the lens release button. Right at the bottom is the focus mode selector: **M** is the setting for manual focusing (with electronic in-focus indicator, provided the lens in use is fast enough); **S** is the setting for single servo autofocus mode and the release can only be activated if the subject is correctly focused (unsharp pictures are thus impossible in this mode); and **C** is the setting for continuous servo autofocus mode.

Looking inside the camera from the front: at the top are the seven contacts for AF lenses. These are used to transfer data from the lens to the camera such as maximum aperture, focal length, and setting distance for focusing. These values are then used by the AF computer to calculate the necessary focusing values. In the centre left is the aperture coupling lever which stops the aperture down to the selected working value when the shutter release is pressed. Beneath, on the flange itself, is the AF coupling for automatic lens focusing. On the right-hand

13

Operating elements of the Nikon F-801

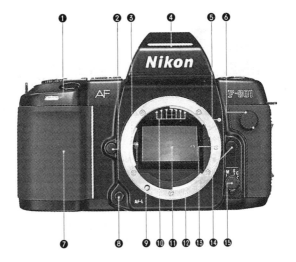

1. Self-timer indicator LED
2. Depth of field preview button
3. Aperture coupling lever
4. LCD illumination window
5. Lens mounting index
6. Remote control terminal
7. Handgrip

8. AFL (Autofocus Lock) button
9. AF coupling
10. CPU contacts
11. Reflex mirror
12. Lens mounting flange
13. Lens release pin
14. Lens release button
15. Focus mode selector

32. Exposure mode button
33. Metering system selection button
34. Multiple exposure/film rewind button
35. Film rewind button
36. Exposure compensation button
37. Power switch
38. Shutter release button
39. Film speed button
40. Film advance mode button
41. Self-timer button
42. Accessory shoe
43. LCD panel
44. Command input control dial

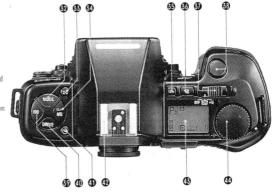

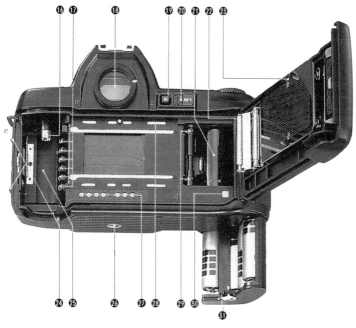

16. Film rewind fork
17. DX contacts
18. Viewfinder eyepiece
19. Viewfinder illumination button
20. AE (auto exposure) lock lever
21. Film takeup spool
22. Film pressure roller
23. Film pressure plate

24. Camera back lock releases
25. Film cassette chamber
26. Tripod socket
27. Data back contacts
28. Film guide rails
29. Film sprocket
30. Film leader index
31. Battery holder MS-7

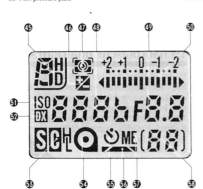

45. Exposure mode
46. Exposure compensation
47. Metering system
48. Shutter speed/film speed
49. Aperture/exposure
 compensation
 value
50. Electronic analogue display
51. Film speed setting
52. DX-coded film speed setting
53. Film advance mode
54. Film installation
55. Self-timer
56. Film advance and rewind
57. Multiple exposure
58. Frame counter/self-timer
 duration/number of multiple
 exposure

15

59. 12mm diameter central area
60. Focus brackets
61. Clear matte field
62. Focus indicators
63. Exposure mode
64. Shutter speed/film speed
65. Aperture/exposure
 compensation
 value
66. Electronic analogue display
67. Exposure compensation mark
68. Ready-light LED

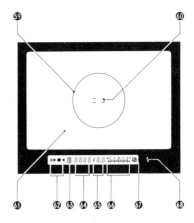

side of the flange is the lens release pin. On the outer edge of the lens mounting flange, on the top right-hand side, is the meter coupling lever for mechanical aperture value transfer (an absolutely essential facility if you want to use non-AF lenses).

Looking inside the camera from the back: on the left is the film cassette chamber with six DX contacts, which are used to read the speed of DX-coded cassettes. In the middle are the shutter blinds which must never be touched when removing or inserting a film as they are very delicate and touching them could cause irreparable damage. Beneath the shutter blinds is a row of seven contacts which are needed when a Data Back is used.

The viewfinder eyepiece is of the new high-eyepoint type. The eyepiece accepts correction lenses, an eye cup, or an eyepiece cover that should be attached to prevent entry of light during long exposures. To the right of the eyepiece is the viewfinder illumination button, but you will rarely have to use it as it is automatically activated in low light. Next to this is the AE (Auto Exposure) Lock lever, which can be used in all modes. As long as this is kept pressed the last-metered exposure value will be stored and recalled when the shutter is released, independent of any changes in the lighting conditions that may have taken place between metering and actual exposure.

On the right-hand side of the camera interior is the automatic film threading assembly. This consists of the film take-up spool, the film guide track and the film sprocket roller. The red marker

is the film leader index and indicates how far the film has to be pulled out of the cassette to be properly loaded. The film pressure plate on the inside of the back cover must also never be touched, because if this is distorted the film cannot lie completely flat. When the back cover is closed you can see through the film window if a film is loaded.

Looking at the camera from below there is the battery holder and the tripod socket.

Looking at the top of the camera with the lens pointing forward, we see on the right, on the top of the handgrip, the shutter release button. This is a multi-function control: it serves as the switch for exposure control and autofocusing, as the trigger for motorized film advance, as well as the release for the shutter. Pressing the release lightly, i.e. to first pressure position, activates the exposure meter and the autofocus system, when the LCD will light up at the bottom of the viewfinder. This means that the exposure control will take a reading to set the aperture and shutter speed, and the autofocus function takes a distance reading, which is used by the autofocus motor to set the focus of the lens. The shutter is released by fully pressing the release button. After the exposure has been made the film is automatically advanced to the next frame.

Behind the shutter release button is the main or power switch. This has three positions. One **off** and two **on** positions. The **on** position to the right also activates an audible signal. Beep tones will sound to draw your attention to "end of film"; "film rewinding completed"; and "self-timer counting down". Then there are warning tones for danger of camera shake (shutter speeds longer than ⅟₃₀ sec.); over- and underexposure in the automatic exposure modes; and if a film cassette is loaded with damaged DX-coding, or without DX-coding, and if the film transport is not functioning. No audible signals will sound if the switch is set to the centre position.

To the left of the main switch is the button for manual exposure compensation (‹‹+/—›› symbol) and the button to activate film rewind (cartridge/arrow symbol). Behind them is the large command input control dial. This may be used together with one of the function selection buttons (i.e. the exposure compensation button or the DRIVE button) to change the settings or mode of that particular function. Next to it is the

central LCD panel. All values and functions active at a particular time are displayed simultaneously on this panel. The small symbol at the edge of the camera body between the display panel and the command input control dial indicates the film plane. This may be useful for copying or macro photography. On top of the viewfinder prism is the accessory shoe with flash contacts. Automatic flash modes are possible with all modern Nikon system flashguns. With the special AF flashguns it is even possible to use automatic focusing in complete darkness. The accessory shoe of the F-801 has a fourth contact for this purpose.

On the left-hand side of the viewfinder prism is the cluster of buttons for the four main functions of the F-801. By pressing the **MODE** button, you can choose one of the various shooting modes that the F-801 offers. **A** stands for aperture priority mode when you preselect the aperture and the camera adjusts a suitable shutter speed; **S** is shutter speed priority with preselected shutter speed and automatic setting of the aperture; **P** is the normal program mode, i.e. automatic setting of shutter speed and aperture; P_H is the high speed program mode; P_D is the dual program mode, i.e. automatic change of mode to P_H for focal lengths longer than 135mm; **M** is manual setting of aperture and shutter speed. The **ISO** button is used to either let the camera read-in the DX-code from the film cassette or manually to set a film speed of between ISO 6 and 6400. The **DRIVE** button, together with the command input control dial, selects the mode of film transport between **S** for single frame; and C_L for Continuous Low, which means a speed of approximately 2 frames per second; and C_H for Continuous High, for a speed of approximately 3.3 frames per second. The **ME** button, together with the command dial, permits the setting of multiple exposures of up to 9 per frame. This button also serves as the film rewind release. To rewind the film this button has to be pressed simultaneously with the film rewind button. During rewinding the frames are counted down on the LCD panel.

In front and to the right of this cluster of buttons is the metering system selection button for either centre-weighted or matrix metering. Behind that is the self-timer button. By pressing this button and moving the input command dial a period of between 2 to 30 seconds may be selected on the LCD panel

as the countdown time. After selecting the timer duration press both this button and the shutter release simultaneously to start the self-timer sequence. The exposure values displayed at the time of pressing the release remain active for the whole self-timer sequence. If autofocus was used before starting the self-timer, then this will also be retained. If focus was not set then the autofocus will check and read just before the shutter is released. Pressing the release a second time will cancel the self-timer sequence. It is possible to take two consecutive self-timer pictures with the F-801; just press the self-timer button and rotate the command dial to select **2F** in the LCD panel and the shutter will be released twice with a 5 second duration between shots.

To cancel any special settings and to return to normal program mode, simultaneously press **DRIVE** and **MODE** buttons. The F-801 is now set for dual program, single frame, and matrix metering.

Now let's look through the viewfinder. In the middle is the outline of the rectangular metering field which is the autofocus

The solitude of a large town well captured with a wide-angle lens and a long exposure time. A tripod was used to avoid camera-shake.

Photo: Rudolf Dietrich

target area. The surrounding 12mm diameter circle indicates the area of centre-weighted light metering. The matte field in this region of the focusing screen is specially useful when manual focusing is necessary. Below the matte field is the LCD panel: from the left are the symbols for AF focusing; then display for active exposure mode; then the shutter speed and aperture value. Although the F-801 is capable of calculating and using intermediate aperture values, the *displayed values* are rounded-up or down and therefore are approximate. The analog bar display on the right appears only when necessary; in manual exposure mode to indicate deviation from correct exposure levels; in the other exposure modes as an over- or underexposure warning; for fill-in flash photography to indicate the relative brightness of background to foreground. In manual exposure the +/− symbol will also appear and the bar display will show the selected compensation value. At the far right is the ready-light LED flash symbol. To save energy the F-801 will automatically switch off the displays in both the panel on the top of the camera and in the viewfinder after 8 seconds. They can be reactivated by pressing the release.

Electronic Setting − Clear and Simple: At first glance you may be taken aback by the idea of electronic technology taking over the traditional camera settings. I too was sceptical at first as I thought the computer-like keying-in of numbers used on some cameras that claim to be high tech quite idiotic. However, if we consider the great wealth of functions available on the F-801 (for example the excellent exposure compensation facility from +5 to −5 aperture stops in ⅓-stop intervals) then such a large range of fine adjustments is not possible by conventional means and Nikon have managed to arrange the controls on the F-801 so cleverly that, after a short period of finding my way around the camera, I am now quite enthusiastic about this new trend.

Clear Overview at a Glance − The Central LCD Panel: Let's look more closely at the central LCD panel (see page 16). At the top left is the selected exposure mode: **A, S, P, PH, PD, M**. To the right of it is the type of metering system (centre-weighted or matrix) and any selected exposure compensations.

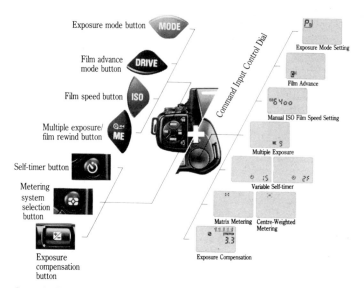

Controls: Exploded view of operating buttons and command input control dial.

The electronic analog display is identical to the appropriate display in the viewfinder. The analog display appears only when needed: in **M** mode as an aid to adjust the exposure, in the other shooting modes as a warning of under- or overexposure; with fill-in flash to indicate the balance between main object and ambient lighting. If exposure compensations are made, then the +/− symbol will also be displayed and the analog bar display indicates the selected exposure value in ⅓-stops. Any selected exposure compensation is also displayed as a two-digit number in the second line of the LCD (in place of the aperture value).

At the very left of the second line is the display for film speed. If automatic DX coding is programmed, then **DX** is constantly displayed. If the film speed is entered manually, then the selected value will only be displayed if the **ISO** button is pressed. Next to it in the same line is the display of shutter speed and aperture value. The display is only in rounded-up or -down aperture and shutter speed values (international shutter speed sequence ... ¹⁄₆₀, ¹⁄₃₀, ¹⁄₁₅, ¹⁄₈, ½, 1, 2 sec. ...). The

internally calculated aperture and shutter speed values include intermediate values.

In the bottom line of the display the type of film transport; **S**, **C_H, C_L**, are displayed at the very left. Next to it is the film cassette symbol, which indicates whether or not a film is loaded. The bar symbol indicates whether the film transport is functioning properly. If this symbol blinks, then it means that the film is stuck or broken. Then there is the self-timer symbol and the multiple exposure symbol. Both of these symbols appear only if the appropriate functions are activated. The countdown and the number of multiple exposures are then displayed in the bottom right-hand corner, which is normally the place where the number of frames is displayed. If the film transport symbol blinks, then the film is not loaded properly or it has been exposed and needs changing.

Fail-safe Energy Supply: The F-801 has three motors, one for the film transport, one for the shutter and mirror, and one for automatic focusing of the lens. It will therefore not come as a surprise to learn that the F-801 needs batteries. We have to praise Nikon for the way they have solved this problem. Instead of powering the F-801 with one of the extremely expensive lithium batteries, they have designed it to run on four AA-size batteries that are easily obtainable anywhere in the world. These four cells power not only the motors of the F-801, but also the camera's electronics. The 6V supply (4 × 1.5V) is ample. This is on the assumption that as long as there is enough energy for the motors, there must be enough to measure the lighting conditions. If the voltage is lower than 1.3V per cell, then there is the possibility that the camera will no longer release the shutter. If it does activate the shutter, then it is quite safe, even with exhausted batteries, because the exposure reading and triggering of the shutter itself requires scarcely any energy at all; the main drain on the energy supply is when the exposure has been made and the motor is activated to move the film to the next frame. If the batteries run down and drop below the minimum voltage requirement because of the heavy load imposed by the motor drive, it is still no great tragedy. They will recover and you can take a few more exposures, even with run-down batteries, without the risk of incorrect exposure. You will have to wait, though, between frames until the voltage level

recovers sufficiently.

Nikon specify the use of alkaline batteries in the AA size which are available almost everywhere. Under ideal conditions a fresh set will last for 120 × 36-exposure films. Rechargeable nickel-cadmium batteries of the same size are also quite suitable. However these tend to discharge spontaneously when not in use and should therefore be used with some reservation. The ordinary zinc-carbon batteries may be used in a real emergency. This type of battery does not retain a steady voltage level and performs poorly at low temperatures. They should be used therefore only if absolutely necessary.

If you have already used electronic cameras you will know that the battery's greatest enemy is the cold. This applies to most batteries used in cameras, which are often small button cells. The F-801 is a praiseworthy exception — equipped with four fresh AA-size or a set of freshly recharged batteries it will work in temperatures down to −10°C.

The following rules for the handling of batteries in the F-801 should be observed:

○ Alkaline batteries, size AA, are the most suitable.
○ Freshly charged nickel cadmium batteries of the same size are also suitable.
○ Zinc-carbon batteries should be used only in an emergency.
○ Always keep a set of batteries in reserve.
○ Always buy only fresh batteries. Check the date on them, they should have at least one year in reserve.

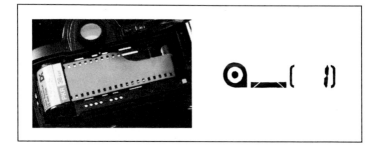

Film loading and rewinding. The F-801 has automatic film loading which works quickly and safely, with relevant information visible in the LCD panel.

Another piece of advice: the automatic cut-off controlling the viewfinder LCD also serves as a battery level indicator. If the display extinguishes after about 8 sec then the batteries are good; if after 4 sec. then you should change them; after 1 sec they have reached the lowest level at which the camera will still function.

Film Loading and Rewinding: Loading the film should present no problems, even from the start. Slide together the camera back lock releases to open the camera back and insert the film cassette into the chamber. Ensure that the film rewind fork is engaged in the cassette. Hold the film cassette down with your left thumb and pull the film end with your right hand until it reaches the red marker. Check that the sprockets are engaged with the perforations of the film, then close the camera back and fully press the shutter release. The film will then be automatically advanced to frame 1. The only problem that you could possibly encounter is if the film has been pulled too far or not far enough. I have loaded a considerable number of films into the F-801 and found that one millimetre more or less makes no difference. Whether or not you have loaded the film properly is immediately obvious. One glance at the film counter in the LCD panel is sufficient. The film transport is electronically checked in the film chamber ensuring that only actually transported film is counted. Should the film be stuck or torn, then this is indicated by a blinking of the film transport symbol on the LCD panel and an additional audible signal if switched on.

Rewinding the film is also very easy. Film advance stops automatically at the end of the roll and the film transport symbol blinks in the LCD panel. Press both the film rewind button and the multiple exposure/film rewind button to activate automatic rewinding. The film transport symbol will be displayed in the LCD panel and the frame counter will count backwards until winding is complete. As soon as the whole film is rewound the frame counter will show **E** and the film transport control will blink.

The F-801 rewinds the film completely into the cassette. If desired, you can send your camera to Nikon and have your F-801 modified to leave the film leader out when rewinding. Personally I think that complete rewinding has more advantages

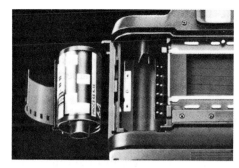
DX-contacts in
the film chamber

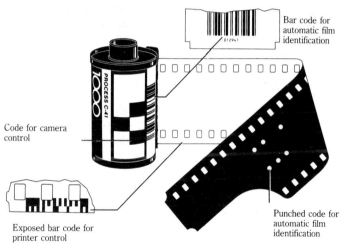

Bar code for
automatic film
identification

Code for camera
control

Exposed bar code for
printer control

Punched code for
automatic film
identification

Automatic film speed setting and DX-coding: the camera computer reads the
resistance pattern of DX-coded film cassettes by the six electrical contacts in
the film chamber and automatically sets the film speed. (Manual setting is also
possible.)

than disadvantages. For example, you will never mistake a fresh
film for an exposed one. Another advantage is that a completely
rewound film does not allow the operator in the processing lab
to pull the film out too fast, a process which could cause
scratches and dust-attracting electrostatic charges, or even
sparks. If it is a high-speed film, about ISO 1000 or faster, and
if it is completely rewound into the cassette, it is conceivable

Film speed button with relevant information in the LCD panel.

that light could enter through the narrow slit and the first few frames may be fogged as a result. As a precaution, cover the slit with some black adhesive tape and place the film immediately in a light-tight container, or wrap it in some aluminium foil to keep it safe.

The film speed is selected by pressing the ISO button and simultaneously turning the input dial until the required value is shown. If **DX** is selected, then the DX-coding will automatically read the film speed on the cartridge. It is capable of reading DX codes of between ISO 25 and 5000. The manual selection ranges from ISO 6 to 6400. If you wish to check what value has been selected, simply press the ISO button and the value will be displayed in the LCD panel.

The F-801 has, like most modern cameras, the facility to read the film speed automatically. Most cassettes now include a coded strip for this purpose. The code includes the visible bar codes (black lines) indicating manufacturer, type of film and film speed, which are primarily intended for processing purposes at the lab. Similar bar codes may be found on the edges of many films and some have punched codes at the beginning of the film, or on the film leader. Then there is the resistance code, which is conveyed by polished metallic (low resistance) and painted (high resistance) areas which are interpreted by the camera and directly transferred via electrical contacts into the exposure microcomputer. If you load a DX-coded film with the film speed setting on **DX**, it is automatically read and set by the camera.

The camera will warn you if you load a film without DX-coding. The shutter release will be blocked, the **ISO,DX**, and **Err** marks in the LCD panel will flash and an audible signal, if set, will sound. Then you manually have to set the correct ISO value.

Another problem in reading the DX-code could arise if you

are using a film straight from the refrigerator. The condensation could influence the DX-coding and lead to an incorrect reading. The same problems can arise if your fingers are sweaty or dirty. The resistance readings could be wrong and lead to incorrect speed settings. In this case the camera will not warn you! When handling a film care should be taken that the cassette is dry and clean and, in cases of doubt, reset the film speed.

Important Characteristics of the F-801

Bright, Well Laid-Out Viewfinder with Selectable Matte Focusing Screen: The viewfinder is still one of the most important parts of a camera. How else could you assess how much of the subject, and at what size and perspective, will be captured in the picture? The viewfinder of the F-801 is doubtlessly the best available in any SLR camera. This applies in particular to the high eyepoint, which allows the whole of the viewfinder image to be properly assessed even from a certain distance. For the average photographer this is a wonderful and most welcome luxury, for photographers wearing glasses and for sports photographers this is a necessity. Another excellent characteristic is the "Brite-View" focusing screen. Its particularly regular, fine surface allows manual focusing even under poor lighting conditions or with lenses with modest maximum apertures. Another useful facility are the interchangeable focusing screens. The universal focusing screen Type B is supplied with the camera. Type J has a central microprism field. Type E is similar to Type B but has an additional grid and is particularly useful for lenses which require manual focusing. Type E is also useful for general photography as the grid is a useful focusing aid for proper alignment. In my experience this type of focusing screen is very useful for copying work and to assess converging lines and perspective in landscape photography.

The eyecup is comfortable and protects the eye from lateral extraneous light. Anglefinder DR-3 will be a welcome accessory for copying (with adapter DK-7) and many macro photographers are enthusiastic about the use of a magnifying lens DG-2 (with

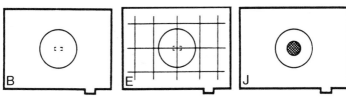

Interchangeable focusing screens: there are three viewfinder screens available for the F 801: type B, type E and type J. It is a simple job to change them.

adapter DK-7) to help them with critical focusing in the close-up range.

Super Fast Shutter Speeds and Variable Flash Synchronization Times: The F-801 offers shutter speeds of $\frac{1}{2000}$ sec., $\frac{1}{4000}$ sec. and the sensational new super-fast $\frac{1}{8000}$ sec! These very fast shutter speeds not only prevent blurred pictures through camera shake but also by fast moving subjects. For example, with the extremely fast top shutter speed of $\frac{1}{8000}$ sec., it is possible to freeze moving helicopter blades. So far this has only been possible by special flash techniques. Nikon were right to introduce the speed of $\frac{1}{8000}$ sec. only after many years of trial runs and tests. Their efforts seem to be fully developed now as their specifications have been verified within acceptable tolerances to be quite reliable. We may now also rely on the stated durability of the shutter for "professional requirements".

The shutter and electronics of the F-801 allow selectable flash synchronization times of between $\frac{1}{30}$ and $\frac{1}{250}$ sec., depending on the shooting mode. This not only allows automatic fill-in flash of excellent quality but also a wide range of interesting speed-blurred effects. This will be described later in the chapters on flash photography.

When using the Nikon SB-24 Speedlight flashgun, an additio-

nal facility is the rear blind sync flash which allows the flash to be triggered just before the second blind closes. The difference between this and conventional flash can be seen in shots of moving subjects with relatively strong ambient lighting. In the former, the movement trace preceeds the moving subject, but in the latter the movement trace follows the subject.

This is how the Focal Plane Shutter works: In order to appreciate the advantages of the super-fast shutter of the F-801 it is useful to know a little bit about the principle function of the focal plane or slit shutter. The exposure times are effected by two blinds which operate in sequence across the film plane. The exposure time of 1 second takes place as follows: the first blind opens quickly and exposes the film completely. Exactly 1 second after the first blind is released, the second follows, and covers the film. Because the area of the film that is exposed first is also covered up first the exposure will be uniform across the whole frame. This technique gets more difficult with faster shutter speeds. After all, the faster the shutter speed, the sooner the second blind has to follow the first to cover the film. A shutter speed of $\frac{1}{250}$ sec. is effected in the F-801 as follows: the first blind opens, reaching the other side of the frame after $\frac{1}{250}$ sec., at which point the film is completely exposed. At this moment the second blind starts to follow the first across. This means that for shutter speeds faster than $\frac{1}{250}$ sec. the second blind has to start to follow before the first has reached the other side. Shutter speeds faster than $\frac{1}{250}$ sec. are therefore not formed by a complete exposure of the film but by a slit of varying width travelling across the film plane. The length is determined by the speed the two blinds move across the film plane and by the width of the slit. At what speed the whole frame is exposed depends on the speed of the blinds. In some cameras this is still as slow as $\frac{1}{60}$ sec. The shutter of the F-801 is a vertical, electronically-controlled, metal, focal plane shutter of special, hard-wearing, alloy. Because the blinds travel across the shorter side of the frame, the shutter is completely open at a speed of $\frac{1}{250}$ sec. and this very fast speed of travel is also the reason for the super-fast shutter speed of $\frac{1}{8000}$ sec.

The flash synchronization time of the F-801 of $\frac{1}{250}$ sec. depends on the described action of the slit shutter. This is due to the fact that the flash can be triggered only when the frame

is fully exposed. If the flash is activated before the shutter is completely open (i.e. at times shorter than ½₂₅₀ sec.) it would result in only partly-exposed frames.

Film Advance: Single, Continuous Low, Continuous High: The F-801 offers three film advance modes: **S** for single frame and **C** for continuous shooting. In continuous shooting mode the camera will keep on releasing the shutter as long as the release is kept pressed. In this mode there are two positions: **C_L** with 2 frames per second; and **C_H** with 3.3 frames per second. The film advance modes are selected by simultaneously pressing the DRIVE button and turning the input dial.

Despite many years of working with motorized winders and motordrives, I have never been able to overcome my dislike for these devices. With good reason because the motorized film transport is much too loud to take candid shots. The motor of the F-801 is by no means the loudest, but its humming is definitely audible. However, as we have opted for autofocus, we are already putting up with the noise from the AF motor, so the additional sound of the film transport must also be accepted.

The motorized film transport is also invaluable for copying and close-ups. Even if the camera is mounted on a tripod, manual winding always disturbs its alignment. To avoid camera shake in this situation it is best to use the self-timer or the electric remote cord MC-12A.

Then there is the pleasure of a sequence of shots of moving subjects. I find the motor drive invaluable when trying to catch a wedding party coming out of church; action on the football

pitch; or children at play — in all these situations the camera can be kept against the eye without needing to find the subject again after film advance. The subject stays in the viewfinder and the number of successful shots is increased. Which film advance mode you select depends on the subject. The faster it moves,

the more necessary the faster continuous shooting mode becomes.

In conjunction with the film advance modes the F-801 provides two autofocus modes; Single servo and Continuous servo, which are indicated as **S** and **C** respectively on the Focus Mode Selector.

Perfect Multi-Exposures: By pressing the **ME** button and turning the input control dial you can select how many exposures you' wish to take on one frame. This allows the creation of amazing effects. However, if you leave it to chance your reward will most probably be rubbish. Taking multi-exposures requires careful planning. You have to be clear in your own mind what the end-result is supposed to be then you can concentrate on the technique. Where a subject is photographed several times, partially superimposed, you will get bright fringes at the points where the bright subject details are superimposed. This can be quite interesting, but usually it is not desirable. It works best if both subjects are slightly underexposed and the bright areas of the first subject fall into the dark areas of the second subject. The F-801 allows up to 9 multiple exposures on one frame.

Metering and Exposure Range: The film speed set by the camera reflects the control and measuring range of the camera's electronics. For an ISO 100 film this ranges officially from EV0 (corresponding to f/1.4 and 2 sec.) to EV21 (f/16 and ¹/₈₀₀₀ sec.). Unofficially the control range extends even further to f/32 and ¹/₈₀₀₀ sec., provided the lens offers this value. If a fast film is used then the metering and control range is restricted in the lower range. This means, for example, that with an ISO 6400 film the biggest exposure would be f/1.4 and ¹/₃₀ sec. (corresponding to EV6). For the slowest film speed of ISO 6 one can expose down to f/1.4 and 30 sec. (corresponding to EV −4).

Some Useful Hints

The Right Film for each Subject

When buying and storing film there are a few rules worth remembering:

○ Always buy fresh film from a specialist dealer. Out-of-date films in the special offer tray are usually not worth having.

○ If your main interest lies in colour prints, then I would generally use an ISO 200 film, such as Fujicolor Super HR 200 or Kodacolor Gold 200.

○ For colour slides it is advisable to keep two different film speeds in reserve. I would suggest ISO 50 to 200 and then an ISO 400 or 1000 for situations where the light fails or you are dealing with fast-moving subjects.

○ Always keep your spare films in the fridge. Before using one, leave it out for one or two hours to acclimatize, otherwise you could have condensation problems.

○ An exposed film should be processed as soon as possible. If this is impossible then store it in a cool place.

Choosing the Right Film: It is a well-known fact that fine grain of a film is an important criterion. Just project a grainy colour slide onto a 2m wide screen or enlarge a colour negative to a 30×35cm print. It is unpleasant to see the sky, which we are used to seeing as a uniform blue area, broken down into coloured grains. The graininess of a film is generally dependent upon its speed; the slower the film, the finer the grain. Therefore an ISO 100 film will generally be more finely grained than an ISO 200 from the same manufacturer.

Then there is the sharpness, i.e. how many fine details are recognizable in the picture. The sharpness is determined by two factors: the resolution and the contour sharpness. The resolution is a measure of how many fine parallel lines may be distinguished per millimetre. The contour sharpness defines

Photographing means more than just releasing the shutter. The atmosphere has been captured well in this shot. *Photo: Wolf Huber*

how sharply the bright/dark edges of the subject are reproduced in the picture. Both of these factors depend, amongst others, on the graininess of the film. This explains why it is impossible to find an exceedingly fast film, that also has good contour sharpness. As a rule the ISO 100 film will always produce better sharpness than the ISO 200 of the same make. If we now compare films of the same speed, but from different manufacturers, then we find that while some will tend to be better in respect of graininess, other excel in their sharpness. So, for example, Fujicolor Super HR 200 is finer grained than Kodacolor Gold 200, but Kodacolor is better as regards sharpness. If we disregard colour rendition and concentrate only on sharpness and grain, then the finer grained film will be better suited for portraits, a case where a large grain is particularly unpleasant. If you are concentrating on a series of shots of landscapes, on the other hand, then Kodacolor will produce better results by showing finer detail.

Exposure range is another important criterion in the consideration of film quality. Until recently it used to be considered the norm to accept a subject contrast of 1:300 (i.e. details could still be discerned in the light and the dark areas, where the lightest tones are 300 times lighter than the darkest ones). Improvements in photographic emulsions presented us with a new generation of films with exposure ranges of up to 1:1000 and more. This wide range is beneficial in other respects. The greater the exposure range of a film, the greater the exposure latitude. Subjects with medium contrast (ca 1:30), may in this way be overexposed by up to two stops, or underexposed by up to one stop on Fuji Super HR 200 or Kodacolor 200, without affecting the final picture quality. Even two stops underexposure and four stops overexposure should result in some quite acceptable pictures. In cases where the available light is not quite sufficient, you can expose ISO 200 film as ISO 400 or even ISO 800, without fear of producing a bad picture. Therefore I suggest using these films as universal film for most situations. The same does not hold true for colour slide films. These have much smaller exposure ranges and will show noticeable

Matrix metering and autofocus (with focus priority **S***) work well even in difficult lighting conditions.* *Photo: Michael Huber*

deterioration in quality by under- or overexposure from as little as ⅓ to ⅔ stops depending on the type of film.

On the subject of colour rendition opinions can differ. This is definitely a question of personal taste and not an objective criterion. One thing is obvious — the colours should be correctly reproduced — carmine red should be carmine red and orange-red should be orange-red, but if all the red nuances are reduced to the colour of ketchup, then this is a sure sign that the quality of the film is not what it might be! Not only the hue but also the saturation should be correctly reproduced. However, modern colour technology is capable of producing quite satisfactory saturation. The glowing colours of a landscape will immediately indicate beautiful weather to the viewer. A slight over-emphasis of brighter colours may also be an advantage in poor weather shots, which counteract an overall impression of dreariness.

Universal Colour Print Film: Provided a colour print film is properly exposed and correctly processed in the lab, an enlargement of a colour negative will produce better colour reproduction and greater variety of colour tones than an enlargement of a slide. This applies not only to subjects with average contrast but also to subjects with high contrast. The strength of colour negative film lies in the prints it can produce. This is true even if the quality of the prints from the large processing laboratories is not always the best. Although this problem also exists for slide film, as these too are not always perfectly processed, the results are usually better. The reason for this is that the colour print has to undergo three stages: film development, enlargement and printing. This means that there are two more steps where the quality can deteriorate. The answer to the question of whether to use slide or print film must therefore be answered purely by which medium you prefer; a print which may be easily displayed or the quality of the projected image.

Slide Film — The Specialist's Medium: The projected image of a good slide has colour and tonal reproduction that is unrivalled by any other form of photographic reproduction. The glowing colours and the fine detail in light and shade are reproduced in unsurpassed brilliance and vividness. The reason for this is that slide film is higher in contrast than a colour print.

Mother and child is a very common subject. The charm of this photograph lies partly in the intentionally large grain. Photo: Rudolf Dietrich

But because slide films are high in contrast they are very sensitive to incorrect exposure. Half a stop under- or overexposure can have adverse effects, especially with high-contrast subjects.

No Need to Overdo Film Speed: Modern ISO 1000 and even ISO 3200 films are surprisingly good with respect to sharpness and graininess, but technological progress increases our expectations and the quality of lower speed film has improved in line with that of the high-speed ones. The latest improvements have created a range of low and medium speed films of excellent quality, such as Kodacolor Gold, Fujicolor Super HR, Agfa XRG and Konica SV-R. Scotch have also improved their HR films. Real improvements have also been made in the area of slide film in recent years with Fuji RDP 100, Kodak Ektachrome 100 HC, Agfa CT100 and Scotch Colour Slide 100.

It is not a good idea to simply reach for the fastest available

film. On the contrary, particularly for slide films, greatest possible sharpness and best reproduction are of the utmost importance and an ISO 50 or ISO 100 is still the best choice. For colour print films, on the other hand, the ISO 200 film speed is particularly highly developed and may be recommended as the universal application film.

If you are taking pictures under low lighting conditions, or if your subject is moving fast, perhaps in sport or play, then you would be well advised to use an ISO 400 or even 1600 film. Even if you are holidaying in the sunny south, it is always a good idea to have a few fast films handy. After all, an ISO 64 would be totally unsuitable at the fiesta or when snorkeling.

It seems quite obvious that if you photograph in low lighting conditions the best films to use are the ISO 1000 and ISO 1600 films. However, be careful not to overestimate the capability of these speeds. In a normally lit living room, using an ISO 1000 film, you cannot give any less exposure than 1/60 sec. at f/2.8 and the lighting conditions in a normally lit gymnasium would not be any better. Even very bright floodlighting will only give a few extra stops. Another aspect that is often not sufficiently appreciated is the irregular, poorly lit area of a general subject. The question therefore is whether a gain in film speed equivalent to one or two stops compensates for the advantages of the finer grained and well-tried ISO 400 film? One should never choose the film according to the premise "as fast as possible to allow for exposure reserves". Better: "always choose the speed that is just fast enough to stay within the limits of camera-shake if the lighting conditions are poor".

Agfa, Fuji, Kodak, Konica or Scotch: For the past 10 years I found I had to pay the extra money for Kodachrome 64 or the Kodacolor II. Qualitatively there was no real alternative. The competition today is between Agfa, Fuji, Kodak and in the meantime Konica and Scotch too have improved their quality to the same level. If you are taking pictures mainly for the family album and the fine nuances in colour and sharpness are not of the utmost importance, then you can buy any film that is on special offer. The question, which film to choose, becomes a little more difficult if you are faced with a subject that is either difficult to shoot or demands the best possible treatment. Then

you have to consider the question if sharpness is of the utmost importance, do I pay a little more to buy the well-tried Kodachrome 64 Professional, or do I choose the Fujichrome RTP 100 for its excellent and full colour saturation which, moreover, costs only half as much as the Kodachrome? The above example should demonstrate that the ambitious photographer does not only ask about the price but he also decides on the film by its qualities and his own photographic requirements.

Black-and-White − Still the Modern Medium: Modern colour photography is less problematic and much cheaper than traditional black-and-white photography. Badly developed colour slides are a rarity and if you use colour print film, you usually get reasonable quality from your processing lab. If you pay a little extra you can even demand top quality. Black-and-white prints, on the other hand, are very expensive and almost unobtainable.

Apart from those facts, black-and-white photography is an art in itself. The colours and contrasts of the subject have to be translated into tones of grey. But if you wish to express yourself in this medium you will almost certainly have to set up your own darkroom and do your own processing and printing. It starts with developing your own film, which has to suit the type of film used, then you have to use the correct type and grade of paper to produce a good enlargement. Then there is a whole range of little tricks, such as shading, masking, and so on. But this necessity to print your own pictures need not be a disadvantage; on the contrary, it can be a great source of enjoyment and satisfaction. If you want to try black-and-white photography, then I would recommend you use Ilford XPI film. This is a monochrome film using colour technology. It handles high contrast subjects and has a large exposure latitude. You can have it developed by one of the large processing labs to which you send your colour films.

Correct Film Exposure: You are often given advice, such as: "Slides should always be underexposed, but colour print film should be overexposed". Such a sweeping statement can only be wrong. The only good advice is that the important parts of your subject should always be exposed as precisely as possible.

A good photograph is more than just capturing a situation. "Welcome to the Free West!" could easily be the title for this picture. No caption is needed. Photo: Rudolf Dietrich

Any deviations from this rule can only be made under special circumstances, being:

○ In case of doubt it is better to overexpose a colour print film, rather than underexpose it.

○ If the light is insufficient and you have no other alternative, then you may underexpose modern colour print films, such as Fuji or Kodak 100 and 200, by up to one f/stop.

○ Colour slide film has to be precisely exposed at all times. In case of doubt, a slight underexposure is better than slight overexposure.

Photography with Automatic Exposure Compensation

There are situations where you cannot rely on the camera's automatic exposure facility. The exposure compensations necessary in such special cases requires a certain amount of experience. Even the experienced photographer does not always want to change over to manual exposure. Exposure bracketing is also not always a good solution as this uses up a lot of film and is not possible for every subject. In such cases the F-801 will perform the necessary exposure compensation based on a measurement by its multi-field metering system.

Matrix Metering – The Standard Metering System It is possible to change the type of exposure metering in the F-801 by pressing the metering system selection button and at the same time turning the command input control dial. The choice is between centre-weighted average metering and matrix metering. The five-field matrix metering system can be used in all the exposure modes of the F-801, regardless of whether it is the program mode, shutter speed mode, or aperture priority mode, with or without auto exposure lock, and even in manual exposure control. In this metering mode the F-801's microcomputer calculates the metered values of the five fields in such a way, that it results in automatic exposure compensation, even with difficult subjects. Therefore there is no need either to calculate any compensation values or select any corrective measures on the camera!

Note: Matrix metering is only possible if you use AF Nikkor lenses or Nikkor lenses with integrated microprocessor (CPU), such as the 500mm, f/4 IF P. If you use any other Nikon lens then the F-801 will automatically change to aperture priority mode with centre-weighted average metering. This is indicated by the exposure mode symbol flashing in the LCD panel.

Nikon is no newcomer to multi-field metering. The Nikon FA possessed a similar five-field metering system which performed very well in many situations. However, there were still some areas where it did not work properly. The next development was the F-401, which possesses three-field metering, and works better than the one in the FA thanks to modern microcomputer technology. In the F-801, five-field metering is

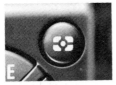

Metering system
selection button

Command input
control dial

Centre-weighted
integral metering

Matrix metering

combined with the most modern computer technology and promises to be an improvement on the previous models.

Matrix metering is a development of an earlier Nikon multi-field system, their automatic multi-pattern metering (AMP). Nikon describe their newer matrix metering as follows: 'the meter automatically provides the main subject with correct exposure in any lighting situation without having to use manual exposure compensation. The matrix metering sensor consists of five segments and determines scene brightness by dividing the scene into five areas analysing each area for (1) brightness and (2) scene contrast. According to these key data, the scene is classified into one of 25 matrix "boxes" each containing one or more algorithm patterns. Depending on other scene information, the F-801 chooses the appropriate algorithm.

An alternative centre-weighted integrating metering system is provided that can be relied on to give satisfcatory exposure indications with the majority of subjects. Systems like matrix metering are designed for dealing with subjects of unusual tone distribution such as where the main subject occupies about a third of the picture area against a very dark background and the rather small dark object in front of a very light background. No such metering is infallible and they cannot cope with every kind of unusual tone distributions although they may help to increase the proportion of successful exposures compared with that achieved by conventional integrating metering with centre

weighting.

Such compromise systems cannot compete as regards efficency with genuine spot metering which offers foolproof exposure control but at the cost of time-consuming application and the need for highly sensitive light sensors for measuring very small subject areas under the lowest lighting conditions.

In an Emergency – Manual Exposure Mode: If you wish to improve on the matrix metering, then you will have to use centre-weighted average metering and manual exposure mode. In this case the use of a grey card or format-filling metering of the main subject is very important. Further information about the matrix metering may be found in the chapter "Basic Principles of Exposure".

Automatic Focus Photography

Leaving aside any individual eyesight defects, automatic focusing is now faster and simpler than ever before. The autofocus facility in the F-801 has been improved compared with the F-501 and F-401. This was possible due to the improved sensitivity of the metering system, which was already excellent in the F-401, and the revised focusing program of the AF microprocessor. In my experience there are only a few borderline situations left where the autofocus is unable to cope. I also welcome Nikon's decision to reduce the focus target area in the F-801. This is contrary to other manufacturers who have enlarged the AF target area in their systems. It is true that the larger the AF metering area, the safer the autofocus function. The only problem with a large metering field is that the AF facility may focus on a subject detail which is not really the one that the photographer intended to target. The large AF metering field is more suited to the requirements of the amateur snapshot photographer. The F-801, on the other hand, is intended to be a camera for the professional or experienced photographer who is capable of making certain decisions himself. The small AF target field is ideal for focusing precisely on a small area.

Using Autofocus: This facility of the F-801 has three modes: **S**, **C** and **M** activated by the focus mode selector. **S** means

Too close

Correct

Too far

Not possible
by autofocus

Focusing indicators for
autofocus mode

Single Servo Autofocus and it makes unsharp pictures impossible because the shutter will only be released if the subject is correctly focused. In practical application this means you point the camera so that the important detail lies within the small AF target field at the centre of the screen, press the release lightly and watch for the round in-focus symbol in the viewfinder display. This focus setting remains in the camera's memory, as long as the release is kept lightly pressed. To release the shutter press the button fully down. No exposure can be made if you fully press the release before the in-focus confirmation appears. The same holds true, if the lighting conditions are too poor, if the subject lacks contrast or is confusing, and the camera is unable to obtain the correct focus. Non-AF lenses can also not be used in this focus mode. In this case the the warning cross to indicate that it is "not possible to focus by AF facility" appears in the viewfinder display.

C means Continuous Servo Autofocus, and in this mode the F-801 will continually adjust the focus for the moving subject. Let's say you are photographing a child running towards you, or you are panning (following the child's movements with the camera), then the autofocus will continue to adjust the focus setting and you can release at any time to make the exposure. In this mode the F-801 functions in release priority, i.e. you can release even if the subject is not in sharp focus. If you select

small apertures, i.e. large f/numbers, you will still obtain sharp pictures even of very fast moving subjects, as the depth of field will allow for minor inaccuracies in focusing.

Depending on subject brightness, contrast, distance and attached lens, focusing in **S** and **C** modes generally takes only ¹⁄₁₀ sec., but it can be a bit longer under less favourable circumstances.

In **M** mode, which means Manual Focus, you obtain the correct focus by manually turning the focusing ring on the lens. If the lens has an **A-M** switch, set to **M**, and a speed of f/5.6 or faster, then the AF facility will assist you in your task by indicating in the viewfinder display with arrows in which direction you have to turn the ring to obtain correct focus. If the subject is poorly lit or unsuitable for autofocus then you will have to rely on your assessment of the image on the focusing screen.

Choice of Frame with AF Lock: An off-centre main subject presents no problem. You start as usual, by bringing the main subject within the focusing field in the centre of the viewfinder. Then you lightly press the release to allow the autofocus to operate. As soon as the in-focus indicator lights up in the viewfinder display you re-align the camera to select the framing that you actually want. The release is lightly pressed all the time, which keeps the focus in memory and set on the lens, until you finally press it fully to take the shot. Should you decide not to make the exposure after all then this is no problem either. Simply take your finger off the release button and the stored setting will be cancelled. Now you are free to focus on a new subject, lightly pressing the release again to initiate a new focusing sequence. Another possibility in AF mode **S** is to press the AF-L button (autofocus lock) after pointing and focusing. The metered and set focus value remains in memory as long as the AF-L button is kept pressed. With this facility you can make as many exposures as you wish with one focus setting. If you wish to take so-called long-time storage of focus setting you simply change the focus mode selector to **M** after focusing. This description may sound a little cumbersome; however, in practice it is quite simple.

Focus or Release Priority? The Choice Depends on the Subject: Extremely fast subjects can be a problem for the autofocus facility. Consider a cyclist racing towards you. If you are trying to catch him in AF mode **S**, then it will be pure chance if you catch him in sharp focus; most probably the release will be locked all the time, or you will get a sharp picture of the background. In situations like these it is better to change to focus mode **C**. In average lighting conditions and using a reasonably fast film, say ISO 400, you will be able to use reasonably small apertures and the moving subject will almost always lie within the depth of field.

The AF modes should therefore be used as follows:

○ AF mode **S**: for composed shots such as portraits, architecture, landscape, and also for reportage, as long as the action is not too fast. Short to medium focal length lenses and film speeds to ISO 200 are usually sufficient.

○ AF mode **C**: for fast action shots as in sports, dance, and play, together with medium to long telephoto lenses and higher speed films.

3 x Depth of Field Trap: With the F-801 you are equipped to use three types of depth of field trap: with release priority, manual focusing or self-timer.

To use depth of field trap with release priority you point the camera, in AF mode **S**, at the required subject detail and fully press the release. The exposure will automatically be made without any delay as soon as correct focus has been set. This method is also suitable for moving subjects, because the camera

will only release when the correct focus is set. This method works very well and you might even be faster than a professional sports photographer with manual prefocusing. If the moving subject moves out of the centre of the frame during focusing, or if it moves too fast, then this method could result in some failures!

To use depth of field trap in manual focusing you set the AF mode selector to **M**. You are still able to use the in-focus indicator in the viewfinder to tell you when the subject is in sharp focus. Preset, on the focusing ring of the lens, the distance setting where you expect to shoot the moving subject. Now press the shutter release to first pressure point and wait for the subject to move into sharp focus. If you release exactly when the in-focus symbol lights up then you have "trapped" the subject. This should be the simplest and fastest method and suitable for many situations. You don't even need an AF lens.

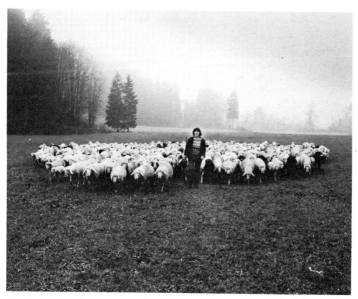

In the past this view of a shepherdess in Allgau may have been considered boring. Today, when many of us dream of getting back to nature, it has a great appeal. Photo: Rudolf Dietrich

The only difficulty lies in the exact alignment of the subject with the AF target field. Supporting the lens on a tripod or a suitable firm support may be the answer.

To use the depth of field trap with the self-timer and to be able to leave the equipment, for example to photograph a fox as he comes out of his liar at night, you will also need the MF-21 Multi-Control Back and the MC-12A Electronic Remote Release. Non-AF lenses of sufficient speed may be used with this set-up. Set the F-801 to AF mode **M** and the MF-21 to **FCS PRIOR**. The MC-12A Remote Release has to be left in the locked position. Now the lens is prefocused on the desired distance and the release pressed. The camera will automatically release when your quarry moves into the focusing plane. This method is also very handy for recording laboratory tests.

The self-timer is always ready for use but the number of seconds delay required has to be set. Press the self-timer button to the left of the pentaprism housing and rotate the command input control dial until the required number of seconds from 2 to 30 appears at the bottom right of the LCD. To use the self-timer, its button has to be pressed while the shutter release is operated. The indicator LED will flash and an audible signal can be heard if the main switch is set at the far right position. Just before the shutter releases the flashing and the audible signal speed up as a warning. The self-timer button can be released along with the shutter release button about one second after the indicator LED starts flashing. If it is wished to cancel the exposure, press the self-timer button again and the run-down stops.

Focusing in Complete Darkness: There are situations where not only the autofocus goes on strike, but also the human eye. In situations like this reach for the AF flashguns SB-20, SB-22, SB-23 or SB-24. These flashguns have an additional special AF infrared flash (AF illuminator) in addition to the normal flash functions. This means that if the F-801 is set to AF mode **S** and you press the release button, the AF flashgun will send out an infrared flash to illuminate the subject if the lighting is insufficient for the AF mechanism to take a reading. This will be emitted until a satisfactory setting is achieved. This arrangement guarantees a sharp flash picture. If you do not wish

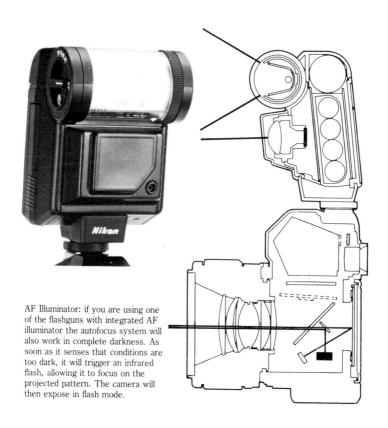

AF Illuminator: if you are using one of the flashguns with integrated AF illuminator the autofocus system will also work in complete darkness. As soon as it senses that conditions are too dark, it will trigger an infrared flash, allowing it to focus on the projected pattern. The camera will then expose in flash mode.

to expose with the flash you can switch the flashgun off, but always keep your finger on the release to retain the AF setting. Moreover, you could then change to manual focus mode **M** and use the stored AF setting to take the most beautiful available light shots in any exposure mode that seems appropriate for the subject. The AF flash focusing method has further advantages. The focusing flash projects a vertical striped pattern and is therefore useful for focusing subjects with low contrast. You may consider this facility totally useless, as you cannot see much in total or near total darkness. Not so, the infrared focusing light includes visible light and the focusing flashes – impulses to be precise – are long enough to be clearly visible in the dark. You

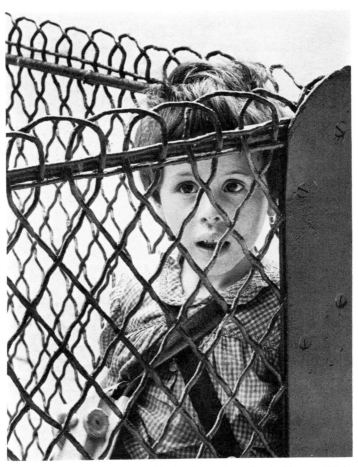

Limits of autofocus: in situations like this the autofocus does not know which is the important detail to focus on, the face of the child or the fence.

Photo: Rudolf Dietrich

Almost any automatic exposure mode will let you down for such a white on white subject. The pictures taken with matrix metering (top right and left) are underexposed by about 1 to 1.5 stops. Even with centre-weighted metering (bottom left) the shot is still underexposed by one stop. As a comparison I have included (bottom right) a manual exposure with fill-in flash. *Photos: Michael Huber*

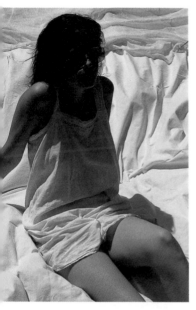
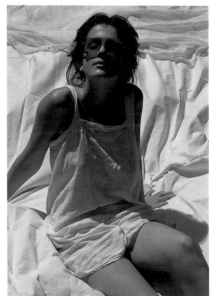

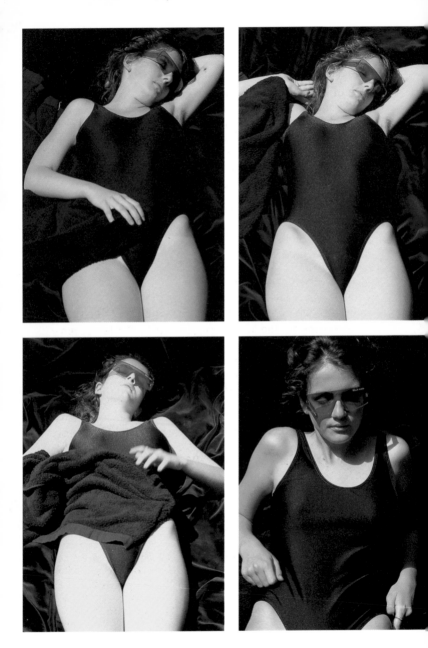

can make out the subject you are focusing on quite clearly up to a distance of 5m. To assess the situation you should not look through the viewfinder but directly at the subject.

Limits of Autofocus: The method for distance metering used by the AF mechanism is passive. This means that the sharpness of the subject is assessed as the image projected by the lens. The required adjustment of the lens is calculated by the AF minicomputer. In order for the autofocus to work, the subject has to possess a certain minimum contrast, and the image produced by the subject through the camera lens must not be too dark.

The following requirements can be summarized for proper functioning of the AF function:

○ a clearly-defined subject
○ sufficient subject contrast
○ sufficient subject brightness
○ adequately large lens aperture
○ a not too large angle of view (no extreme wide-angle lenses)
○ no heavily light-absorbent filters or special effect filters.

Let us first consider the lens speed. The Nikon AF lenses have a speed of at least f/5.6. The AF mechanism could not function with speeds slower than this, i.e. f/8 or f/11. Slow lenses are unsuitable for AF photography. The autofocus needs a relatively wide beam of light to recognize the sharpness. In lenses with slow speeds the beam of light is rather narrow. This will not apply to AF lenses as they have been designed with these constraints in mind but if you are using some other Nikon lens, which is quite likely as it is one of the advantages of the new AF cameras, you have to ensure that its maximum aperture is sufficient. If you wish to make use of the focusing aid in focus mode **M**, this will not be possible with a lens speed of f/5.6 or slower. The camera indicates this by the flashing cross in the

Matrix metering worked quite well for this black on black subject (top right and left). However, when the black proportion was increased matrix metering was unable to cope! With centre-weighted metering (bottom left) the result was an overexposure by up to two stops. The best result was achieved by full format metering of the face in manual exposure setting (bottom right). *Photos: Michael Huber*

viewfinder display. It is still possible to use such a lens, but focusing has to be done completely unaided on the focusing screen, as in the good old days.

Dimly-lit subjects are also critical. But don't worry unduly. I was able to take successful shots with the F-801 of very dim subjects where it was even difficult to focus manually. Nikon have devised a sophisticated and highly sensitive AF metering mechanism which allows reliable focusing even with subjects with an exposure value (EV) as low as −1. But not only is the level of illumination important, the subject must also be uniformly lit. After all, the AF system only measures the centre part of the frame, and if the main subject is hidden in a dark corner, even the highly sensitive AF mechanism cannot cope. The only solution in these situations is manual focusing. In emergencies you will have to judge the distance and make an approximate setting. If you are lucky enough to possess an AF flashgun, then you can use the infrared flash for focusing.

Subjects with low contrast are another source of problems to the automatic focusing facility. By contrast we mean that the subject has to have dark and bright areas and that these areas have clearly defined boundaries. Just try and focus on a smooth white wall. The autofocus will adjust the lens from close-up to infinity and back again, then the warning cross in the viewfinder display will flash, telling you that it cannot focus.

Another cause of problems is a subject with a profusion of fine contrasty lines, for example, print on a newspaper. Whether this will work or not will depend on the reproduction ratio. Horizontal lines are also not particularly favoured by the AF mechanism. This is because the sensors are aligned to vertical structures, although the F-801 copes better in this respect than the earlier F-501 and F-401 models. Even so, there is an easy way out. Simply turn the camera to the vertical position, take the distance setting, keep the finger on the release to hold it, then re-align the camera for the required framing and take the picture.

Extreme backlit subjects and excessively reflective surfaces could also cause problems because light scatter in the AF target field can reduce the contrast to an inadmissible degree. However, this is rarely the case.

Lenses of extremely short focal length are another source of

problems for the AF mechanism. The large depth of field of the extreme wide-angle lenses irritates the autofocus. The auto-focus is no longer capable of appreciating that there is a range of greatest sharpness also in this case. The autofocus is at a loss, similar to the photographer, who has to check the distance scale on the focusing ring of the lens to be sure of correct focusing.

Lastly we have to consider subjects with confusing spatial relationships. By this I mean, for example, subjects that are staggered in space in a complicated array. Imagine two children, one standing behind the other. Part of the face of the farthest child and part of the nearer child are within the target field. Which child should the autofocus choose? In my experience so far I have found that the focusing system tends to select the closer subject. This preference could be annoying if you try to take a shot through a fence, or the bars of a cage, where you do not want the sharp outline of metal. In such cases it will be necessary to ensure that the important subject detail is placed within the target field, excluding the confusing foreground. With the focusing setting stored, the camera can then be re-aligned to take the shot with the required framing. If this is unsuccess-ful, then there is always manual focusing.

Colour and creative filters could make life difficult for the autofocus in three different ways. Firstly, colour filters absorb a lot of light and thus reduce the effective lens speed (e. g. colour filters, graduated filters, vignettes − there is no problem with UV and skylight filters). Secondly, they reduce subject contrast (e. g. soft-focus filters, fog filters). Thirdly, they may polarize the light (normal linear polarising filters must not be used with the F-801, but circular polarising filters are suitable). I hope my description of unsuitable subjects for AF function will not make you doubt its usefulness and reliability. May I allay your doubts by pointing out, that in my experience I found the AF mechanism more sensitive than the human eye. We can discern subjects only if it is light enough and the details and outlines are sufficiently defined.

Manual Focusing in an Emergency: For subjects that are unsuitable for autofocus, or if you are using a lens that does not operate in AF mode, then you will have to focus manually. The optical path to the focusing screen is equivalent to the path of

the light when it meets the film plane with the mirror folded away. The sharpness on the focusing screen is therefore an excellent indication of whether the subject has been properly focused or not. In principle, a normal focusing screen should be quite adequate; it only needs to be sufficiently fine and uniformly grained. The focusing screen of the F-801 is just that, and has no focusing aids, such as crossed prism indicator or microprism ring, which is more of an advantage than a disadvantage. These focusing aids tend to darken when used with long focus or slow lenses and that makes focusing more difficult, not easier. The focusing screen fitted as standard in the F-801 is straightforward. It is possible to focus even in fading light and using a 500mm, f/8 telephoto lens. If your eyesight is good, or you are wearing good glasses, then manual focusing is still possible, even if the autofocus is unable to operate for any reason.

This is How The Autofocus Works: The AF mechanism of the F-801 basically consists of four modules. The first is the microcomputer in the lens. This conveys the typical characteristic values such as speed (maximum aperture), focal length and focusing distance via the AF contacts in the bayonet to the camera. Within the camera there is the AF distance metering unit (AF Focus IC). This consists of an image converter using CCD semiconductor technology with 200 metering fields. The metering signals from these CCD units are interpreted by a special integrated circuit (IC) and the result is passed to the central microcomputer (CPU) in the camera. The data supplied by the metering unit and those from the lens are combined in the CPU and converted into the appropriate command for focus setting. This instruction is conveyed to the AF servo motor unit. The AF motor drive IC converts these instructions into revolutions and triggers the motor to turn this exact number of revolutions in a forward or backward direction. A light barrier with an interrupt disc counts the motor revolutions and reports them back to the AF Motor IC. The revolutions of the AF motor are transmitted via a gear train and coupling to the lens gear which performs the exact number of revolutions for the distance setting of the lens. As soon as the lens setting is completed the CPU requests a further sharpness reading from the distance metering IC and, if appropriate, passes the message "in focus"

to the IC in the viewfinder. Now the in-focus symbol in the viewfinder display will light up. Under ideal circumstances the whole process from measuring to completed focusing could take as little as $\frac{1}{10}$ sec. If the distance metering IC reports incorrect focusing to the CPU after the lens has been adjusted, which could be the case in poor lighting conditions, or for poorly-defined subjects, then the focusing process is repeated by moving the lens through the distance settings from close-up to infinity. If this is unsuccessful then the CPU reports to the viewfinder and the display flashes the warning cross, indicating that focusing cannot be effected.

To understand how the electronic distance metering, or recognition of sharpness, functions in the F-801, we have to first define what sharpness is. A lens is set to the correct distance if every point of a subject for that distance is represented as a sharp point on the film plane in the camera. If the distance is not correctly set, then the point will no longer be sharply defined and it begins to get bigger and flow into other image points around it.

There are two situations of unsharpness: setting for too close or for too far. For example, if the subject is 5m away from the lens, but the lens is set at 2m, then the light rays from a certain subject point combine in front of the film plane. To obtain sharp focus the lens would have to be turned in the direction of 5m (this is clockwise in the case of Nikon lenses) until the light rays combine exactly on the film plane. On the other hand if the subject was 5m away, but the lens was set to infinity, then the light rays combine behind the film plane. The lens has now to be turned in a counter-clockwise direction towards 5m. The distance metering mechanism in the AF system of the F-801 has the task of measuring and assessing the blurring of unsharp pictures, so that the direction in which the lens will have to be turned can be ascertained. The microcomputer in the camera can then calculate the required distance the lens has to be turned to obtain correct focus. To do this the sensor unit (CCD Chip + evaluation IC) measures the expansion of the image point on the film plane due to incorrect focusing. To be precise, the measurement is not taken on the film plane; part of the light is allowed to pass through the partially transparent mirror and this is projected towards the CCD Chip, the length of the path for

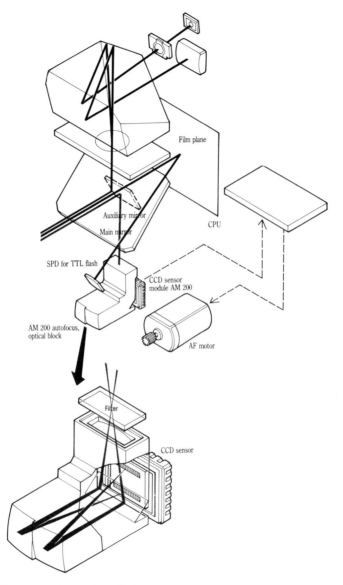

Film plane

Auxiliary mirror

Main mirror

CPU

SPD for TTL flash

CCD sensor module AM 200

AM 200 autofocus, optical block

AF motor

Filter

CCD sensor

Elements of the Autofocus System

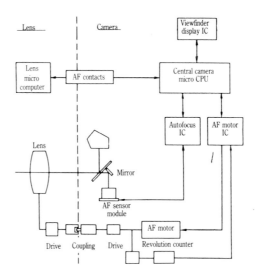

this portion of light is exactly the same as that to the film plane. The trick employed by the AF system is that it consists of two types of metering fields. Type A and type B. A faceted lens is placed in front of each of these measuring pairs, A and B, so that the light beam emitted from the subject point and passed through the lens is split and combined at metering points for each lens half. Let's consider the simplest case with the lens set to the correct focusing distance. In this case the light beam of the sharp image point is projected onto the AF sensor so that the two adjacent metering fields are comprised of practically the entire light beam. Metering field A receives the light from one half of the lens, metering field B receives the light from the other half. The evaluation electronic circuits in the focusing IC compare the two measured curves of measuring points A and B. If the two curves coincide, or to use an electronics term; if the curves are in phase, then the focusing IC reports to the microcomputer "image in focus".

Now consider the case when the lens is set too close and the unsharp image lies in front of the film plane. In this case the blurred image point in the AF sensor illuminates not just one measuring pair, but a whole sequence. As a result, the two measuring curves A and B (to be precise the curves of A measuring field and B measuring field) diverge at the maximum points.

The same thing occurs when the lens is set for too great a distance; the two measuring curves will also diverge, i.e. they are not in phase. But the direction of the divergence for "too close" is opposite to that for "too far" and the focusing IC recognises immediately in what direction the lens has to be turned. This information is transferred to the central microcomputer in the camera. The focusing IC also interprets by way of this phase detection how far the curves are offset or divergent from each other. This provides the measure of how far the lens has to be turned to obtain maximum sharpness. This information is also conveyed to the CPU, and the camera calculates from this information together with the lens data the required lens settings.

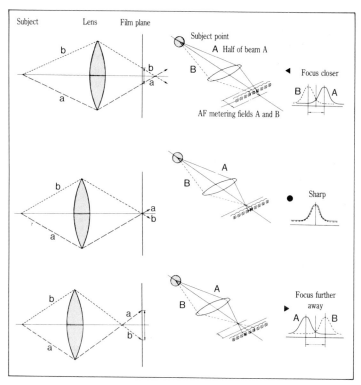

The camera computer recognises by phase detection the direction and amount of the focusing correction.

A cliché is alright, if it's done properly! This picture shows that there is no subject that a serious photographer cannot tackle.

Photo: Rudolf Dietrich

Choice of Exposure Modes

Fully Automatic in Program Mode

The program mode automatically selects a suitable aperture value and shutter speed for the measured subject brightness and the speed of the loaded film. If the F-801 is set to AF mode, then the photographer only needs to point his camera at the main subject and choose the required framing.

Three Program Modes: You have a choice of three program modes:

○ **P**: the "Normal Program" for short and medium focal length lenses with stationary or slow-moving subjects.

○ **P$_H$**: the "High-speed Program" which prefers faster shutter speeds which is useful for longer focal length lenses and fast-moving subjects.

○ **P$_D$**: the "Dual Program" in which the mode is automatically changed to **P** mode if a short focus lens of up to 135mm is attached, and for longer focal length lenses, changed to **P$_H$** (but this is only possible for lenses with an integrated CPU).

A fourth variation is the Flexible Program. This allows you to change the shutter speed/aperture combinations in all the program modes via the input dial, without changing the actual exposure value. This is another facility which enhances the program mode from a snapshot tool to the realms of professional use.

Using the Program Mode: After loading the film set the highest aperture number on the aperture ring of the lens. Then press the **MODE** button and turn the input dial to select **P**; **P$_H$** or **P$_D$**. For the AF mode you would normally choose **S**. Now you can start. If you look through the viewfinder and lightly press the release button, the exposure metering sequence and autofocus mechanism are activated. In the viewfinder at the centre of the display panel, the symbol for the selected shooting mode will appear, either **P**; **P$_H$** or **P$_D$**. To the right of this symbol the calculated aperture value and shutter speed will be displayed. You need not make any more adjustments and can,

provided the autofocus has focused correctly, take the shot.

Incorrect exposures are more or less impossible because you will be warned by the camera computer. Quickly check the display in the viewfinder and you will obtain the following information:

○ If **EE** appears instead of the aperture value, then you have forgotten to set the aperture ring on the lens to the smallest aperture value (= largest aperture number).

○ If **HI** (together with an audible warning) appears instead of the shutter speed, then the subject is too bright, i.e. the setting range of the F-801 has been exceeded and overexposure is likely. This means that the subject is too bright for the speed of the loaded film, together with the smallest possible aperture value of the lens and the shortest shutter speed available on the camera.

○ If **LO** (together with an audible warning) appears instead of the shutter speed, then this is the underexposure warning. The subject is too dimly lit for the loaded film, the longest shutter speed and the widest possible aperture opening. In this case you may have to use flash.

○ If the audible warning sounds, provided this has been activated by the main switch, despite normal shutter speed and aperture values being displayed, then your attention is

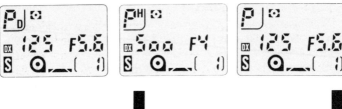

LCD panel and viewfinder information for program mode.

64

drawn to the danger of camera shake. The shutter speed calculated by the camera computer will then be $\frac{1}{30}$ sec. or longer. In this case you will either have to support the camera or use a tripod.

Not All Lenses are Suitable for Program Mode: In program mode, as is the case with all the other automatic shooting modes offered by the F-801, you have to take care that the lens used is equipped with the necessary electronic aperture value transfers. In the program modes it is only possible to use lenses with electronic data transfer (integrated microprocessor or CPU)! Lenses with fixed aperture value, and those which have no transfer facilities for the aperture value, are not suitable for program mode. From the Nikon range, all the lenses mentioned in the chapter on AF lenses, and the 500mm, f/4 P, are suitable for use with the F-801. Please consult the tables in these chapters. If you are using a conventional lens without integrated microprocessor, then the F-801 will automatically change over to aperture priority mode with centre-weighted metering.

For program mode **P**: the most suitable lenses range from a 28mm wide-angle to approximately 135mm medium telephoto lens. Average film speeds are suitable. For colour slides this would most probably be an ISO 100, and for colour print film, an ISO 200 would be your best choice.

For program mode **P$_H$**: In this mode lenses with a focal length of up to about 300mm are suitable. If the lighting conditions are good, you can use an ISO 200 film for colour slides; for colour print film, speeds of up to ISO 400 are suitable. You should also consider that it may be better to use shutter speed priority mode instead of program mode **P$_H$**.

Program Mode for Snapshots and the Family Album: The program mode is perfect for family snapshots, such as children, friends, pets, and for general records of holidays — street and beach scenes, landscapes, etc. In this shooting mode you need not worry about aperture or shutter speed settings and so can concentrate fully on the subject. This type of photography is often looked down on as simple snapshot photography, but it need not be such a negative concept. Natural expressions,

unrehearsed scenes, the fleeting moment caught, all of these presuppose that the photographer acted quickly, without first having to fumble about awkwardly with light meter, aperture and shutter speed settings. It is quite obvious that not every situation and subject is suited to this snapshot technique. Pure landscape photography, for example, will be properly exposed in program mode, but you could encounter some problems with regard to depth of field. If you need to show everything in sharp focus, from close-up to infinity, then you are better using aperture priority mode. You can then select f/16, which will give you greater depth of field than f/4, and the camera will do the rest. To obtain small enough aperture openings in program mode, the subject brightness and film speed have to be quite high and this cannot always be the case. The aperture priority mode is obviously the ideal mode for creative control of depth of field and you should select this mode on the F-801.

A game of ice hockey on a canal at Schloss Nymphenburg near Munich. The contrasts in this subject are extremely high. It was intentional to expose for silhouettes. Photo: Rudolf Dietrich

Moving subjects, for example in sports photography, are generally not very well suited for program mode. The pre-selected shutter speeds are generally too slow for this purpose. Moreover, if you are also using one of the longer focal length lenses, as is normally required to get a close view of the subject, then the danger of camera shake is added to movement blur. You may know this already, but the exposure time should not exceed the reciprocal of the focal length of the lens in millimetres to avoid camera shake. This means that for a 500mm lens, the shutter speed should never be slower than $\frac{1}{500}$ sec. to be reasonably sure that the shot is not blurred due to camera movement. The high-speed program mode **PH** is well-suited for moving subjects of any kind. To ensure that the shutter speed is never longer than $\frac{1}{250}$ sec. in the high-speed program mode, you have to load a rather fast film, at least ISO 400 or faster. You will also need a relatively fast telephoto lens.

The undisputed advantage of the shutter speed priority mode, compared with any program mode, is the considered preselection of the shutter speed. Now you can be absolutely sure that the moving subject will be depicted exactly the way you want, either with some movement blur, or its movement frozen in the picture.

The advantage of the aperture priority mode, on the other hand, is the considered preselection of the aperture. Now you are free to create your image by the well-considered use of depth of field, showing your main subject against a sharp or a blurred background.

The well-considered use of the aperture and the clearly defined depicting of fast subjects define the limits of program mode. If you are interested in the technical background of program mode, then read on in the next section.

Limits of Program Mode: These are, on the one hand, subjects that require the considered use of a certain aperture value or shutter speed, or subjects with extremely high contrast, or of an unusual reflectivity, but these will also require special attention in any of the other exposure modes. In extreme cases even the matrix metering may not function satisfactorily, and then you will have to change to manual exposure. In this case you will have to be fully versed in photographic principles and I have described these techniques in the various chapters

of this book. In all other cases you can rely on the matrix metering and this will definitely be the best and fastest method for good pictures.

For the Expert: Program Mode with Flexibility: After lightly pressing the shutter release button, the aperture value and shutter speed calculated by the F-801's exposure control appear in the viewfinder display and also on the LCD panel. This shutter speed/aperture combination may now be changed by turning the input dial. The actual exposure value will remain unaltered, only the combination of aperture and shutter speed is changed, each of them in the opposite direction in full aperture stop increments. If the displayed values are, for example, f/8 at $^1/_{250}$ sec. and you turn the input dial in the counter-clockwise direction, you will first be given f/5.6 and $^1/_{500}$ sec. as the next possible combination. This manual changing of the program curve is therefore called the Flexible Program. After the shutter has been released or the exposure data has disappeared, the program flexibility setting will be cancelled and the camera functions again in normal program mode.

The experienced photographer may decide to always use this flexibility of moving the program curve to the desired values, instead of changing over to either shutter speed priority or aperture priority modes. If the suggested shutter speed is too slow or the aperture too large or too small, simply change the combination, until the desired value is obtained.

This is How Program Mode Works: It calculates the appropriate exposure for the measured subject brightness and film speed. This exposure value is then automatically applied to a program curve and translated into a suitable aperture/shutter speed combination. The program mode chooses this shutter speed/aperture value combination from a range of possible pairs, corresponding either to the normal or the high-speed program curve. The program curves are shown on page 72.

Beach photographs with a difference: it helps to have a eye for the ridiculous. *Photos: Vanessa Christmann*

But what happens if the lens you are using does not have the calculated aperture value? After all, a lens with a speed of f/4 cannot be opened up to f/2.8 or even f/2 and if you are using a zoom lens with varying speed across the focal length range (e.g. the AF Nikkor 35-70mm, f/3.3-4.5) you could come across some problems. The question is, how does the F-801 react when the program mode calculates, say, f/3.3 and 1/300 sec., but the speed for the selected focal length of lens is only f/4.5? You need not worry, thanks to the microprocessor integrated in the lens, the camera computer is always informed of the effective speed of the lens. The camera computer quickly calculates the real light speed and alters the shutter speed accordingly. This combination may now deviate from the actual program curve, but the resulting pictures will be correctly exposed.

Program Curves in Detail: If we examine the diagrams of the program curves, we can see that this is an exposure value/aperture/time curve. In order to interpret this it is necessary to understand what is meant by exposure value. The exposure value (EV) is a quantity denoting a number of different aperture value/shutter speed combinations. For example, EV8 is equivalent to f/32 with 4 seconds; f/11 with 1/2 sec.; f/8 with 1/4 sec.; or f/2.8 with 1/30 sec. Equivalent here means that these combinations will all produce the same effect with regard to exposure. Further informations on the topics of exposure, aperture, shutter speed and exposure value may be found in the chapter "Principles of Exposure".

Let's first consider the conditions for interior photography in artificial light. If the measurement of the subject brightness with a film speed of ISO 100 results in EV7, then the high-speed program would select an aperture of f/1.4 and provisionally choose a shutter speed of 1/30 sec. If the camera measures EV12, which might be the case for an outdoor picture with heavy cloud cover and using an ISO 100 film, the camera would

select, in high-speed program mode, an aperture of f/2.8 or f/4 and a shutter speed of about ⅓₀₀ sec. If the measurement is EV19, for example an outdoor situation with cloudless sky, bright sunshine and an ISO 100 film, then the high-speed program would probably select an aperture value of f/11 and a shutter speed of ¼₀₀₀ sec.

In normal program mode the situation is similar, only now the program will favour slower shutter speeds with larger apertures. EV7 would result in an aperture of f/2 or f/2.8 and a shutter speed of about ½₀ sec.; for EV12 the aperture has to be stopped down to f/5.6 and the shutter speed increased to ⅟₁₂₅ sec.

What range of the program mode curve the camera selects depends on the film speed. For example, for EV8 and a film

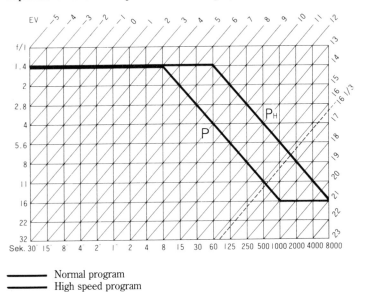

————— Normal program
————— High speed program
- - - - - - Limit of brightness

Program curves: this program curve shows what shutter speed and aperture combination is used for certain exposure values. To read off the aperture you follow the programme curve from the intersection of the oblique EV line through to the left. To read off the shutter speed you follow the line downwards. The diagram shown here applies for a film speed of ISO 100 and a lens with a maximum aperture of f/1.4 and smallest aperture of f/16.

speed of ISO 50, then the camera will automatically select f/2.8 and ¹⁄₃₀ sec. If, however, an ISO 400 film is used for the same subject brightness, it will be EV11. In normal program the camera will select f/4 to f/5.6 and the shutter speed will be increased to ¹⁄₆₀ sec.

To understand the program curves one has to consider which conditions remain constant when photographing and which are variable. If you already have a film of a certain speed in your camera, then the exposure value, which is the base for calculating the aperture and shutter speed, will depend only on the subject brightness. If, on the other hand, the subject brightness is fixed and you are still considering which film to load into your camera, then you will be able to use with a faster film those sections of the program curve resulting in combinations of larger aperture values and faster shutter speeds.

Let us have a closer look at the normal program. We find that if we are using a lens with a speed of f/1.4 it will behave like an aperture priority program calculating exposure values from EV-5 (f/1.4 and 30 sec.) to EV4 (f/1.4 and ⅛ sec.). This means that, although the aperture remains the same, the exposure is controlled by varying the shutter speed. In the case of the high speed program this range extends from EV-5 (f/1.4 and 30 sec.) to EV7 (f/1.4 and ¹⁄₆₀ sec.). From EV18 (f/16 and ¹⁄₁₀₀₀ sec.) the normal program changes over to aperture priority and ends with EV21 (f/16 and ¹⁄₈₀₀₀ sec.). The reason that the normal program stops at a smallest aperture opening of f/16 may be attributed to the fact that most lenses with short or medium focal lengths do not usually have a smaller aperture opening than f/16. According to my own tests, however, the program curve will extend in a straight line up to EV22 (f/32 and ¹⁄₄₀₀ sec.) when lenses with higher aperture numbers are used. This extends to EV23 (f/32 and ¹⁄₁₀₀₀ sec.) and then goes over to aperture priority mode.

For the high speed program the official Nikon program curve ends with EV21 (f/16 and ¹⁄₈₀₀₀ sec.). According to my own tests, however, it will extend to EV23 if the attached lens can be stopped down to f/32.

Whenever the program mode bases its decision on the matrix metering system then the normal and the high speed program ends at EV16⅓ with an ISO 100 film. For this reason the

program curves are continued from this point in broken lines. For faster films the program curves will continue along the broken lines. There are other reasons for restricting the curves to these ranges. Exposure values higher than 16 are very rare for subjects with normal reflectivity in normal lighting conditions. If we take the case of a white sandy beach or a snowscape in bright sunlight, and an ISO 100 film in the camera, then we have a situation where the exposure value would rise beyond 16. If the exposure control now underexposes the scene to compensate for the extremely light subject, then the light sand or the white snow would appear dirty grey in the final photograph. The exposure control of the F-801 automatically increases exposures for such subjects, just as a good photographer would by employing manual exposure compensation.

As mentioned previously, the program modes will consider the effective lens speed. As we have seen above, even the smallest possible aperture opening (i.e. the largest aperture number of the lens) is being considered. The shutter speeds will therefore be a little faster or slower and the aperture openings a little larger or smaller, in many cases, than those stated in the program curves. The program curves are therefore somewhat more flexible than shown.

Fast Subjects with Shutter Speed Priority

The shutter speed priority mode is useful whenever the shutter speed is of importance and the aperture can take second place in image creation. In this mode the photographer chooses a shutter speed and the camera will automatically select a suitable aperture for the subject brightness and film speed. This will often be the case when moving subjects are taken or long focal length lenses are used where camera shake is a problem.

How to Use Shutter Speed Priority: Load the film and set the aperture ring on the lens to the highest number. Then press the **MODE** button and turn the input dial to select **S** in the LCD panel. The AF mode can be chosen according to the subject, either **S** or **C**. Now you can point the lens at the subject, lightly

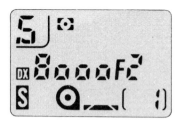

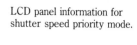

LCD panel information for shutter speed priority mode.

press the shutter release and select the required shutter speed with the input dial. Now the preselected shutter speed and the calculated aperture value are shown in the display panel of the viewfinder and also in the LCD panel. Should you wish to change your mind about the selected shutter speed, simply turn the input dial. The newly selected shutter speed will appear and the camera will automatically recalculate a suitable aperture.

Incorrect exposures are practically impossible because the camera computer will warn you immediately. Checking the display in the viewfinder panel will give you the following information:

○ If **EE** appears, instead of the aperture value, then you have forgotten to set the aperture ring on the lens to the smallest opening (largest aperture number).

○ If **HI** appears, instead of the aperture value and the audible signal sounds, then the subject is too bright and the measuring and setting range of the F-801 is exceeded. Overexposure is likely. The subject is too bright for the film speed, the preselected shutter speed and the smallest possible aperture opening on the attached lens. In this case you have to select a faster shutter speed. By how much the shutter speed has to be changed can be read off the analog display. If even 1/8000 sec. is not fast enough then you will have to use a neutral density filter or accept overexposure. If you are using a colour print film, 1 to 2 stops overexposure should not ruin your pictures.

○ If **LO** appears, instead of the aperture value and the audible signal sounds, then this indicates underexposure. This means that the subject is too poorly lit for the film and the preselected shutter speed, even when the largest aperture value is used. In this case you have to select a slower shutter

speed. By how much the shutter speed has to be changed can be read off the analog display. Another possibility is to use flash.

In shutter speed priority mode you have to take care that the lens used is equipped with the necessary electronic data transfer facilities. From the Nikon range only the Nikon AF lenses listed in the sections on lenses have this facility, as well as the 500mm,f/4 P. If you are using a conventional lens without an integrated microprocessor, the F-801 will automatically change over to aperture priority mode with centre-weighted average metering.

Shutter Speed Appropriate for Sport and Action: Presenting the movement of the subject by precisely-measured movement blur is the domain of the shutter speed priority mode. The only question is, which shutter speed is exactly right for your subject? One thing is quite clear; fast moving subjects and slow shutter speeds are, generally speaking, incompatible. A picture of a racing car, represented as a long red streak, will generally land in the wastepaper basket and not on the photographer's gallery wall. On the other hand, it is not always correct to totally freeze a movement on the film. The petrified gymnast may be of some interest to the trainer, but most of us would not find such a representation very pleasing aesthetically. The art is to expose fast subjects in such a way that they are still acceptably sharp, but without depriving them of all movement. This obviously means choosing the right exposure time. If you have tried in the past and it did not turn out exactly to your liking, let me assure you that even experienced sports photographers can produce work, 90% of which is rubbish! Still, you cannot rely entirely on good luck and happy coincidence.

Movement Blur or Freezing: You could achieve the desired result by using up a lot of film, but it would be cheaper and less frustrating to bear a few helpful numbers in mind. It is possible to calculate in advance at what shutter speed a moving subject starts to become blurred. You will find a table in these pages of popular subjects and blurring of movement. If you wish to show the moving subjects sharper, then you have to keep the shutter speed a little faster than the suggested values. If you wish to make the movement more visible, then you need slower

Blurring due to Movement

Distance from camera to subject (with standard focal length)	Direction of movement to film plane		
	↕	✕	→
Slow movement, pedestrians, children at play, car moving at up to 15 m.p.h.			
4 m	1/125	1/250	1/500
8 m	1/60	1/125	1/250
16 m	1/30	1/60	1/125
Fast movement, fast sports, vehicles moving at up 30 m.p.h.			
4 m	1/250	1/500	1/1000 or panning
8 m	1/125	1/250	1/500
16 m	1/60	1/125	1/250
Very fast movement, vehicles at about 60 m.p.h.			
4 m	1/500	1/1000	1/2000 or panning
8 m	1/250	1/500	1/1000
16 m	1/125	1/250	1/500

exposures than the given times. You first estimate the speed of the subject and then set the appropriate speed on the camera.

By the way, movement of a subject can be demonstrated very effectively to the viewer by showing it sharply against a blurred background. You achieve such results by panning in the direction of the movement. This too will take some practice and you will probably have to sacrifice a few films before you get the hang of it.

If you wish to represent movement by a certain amount of blurring, then the shutter speed priority mode is particularly well suited for it. First you focus on a point which the subject will shortly cross. If this is difficult by autofocus then it will have to be done manually. Preselect the required shutter speed and check again in the viewfinder whether the exposure is correct. Then you are ready to expose at the right moment. Just think

of all the possibilities that the F-801 with its super-fast continuous shooting mode opens up for you!

Limits of Shutter Speed Priority: It is always unsuitable when precisely determined depth of field is an important consideration. This applies to portraits, landscapes, architecture, and macro photography. In these cases the aperture priority is the correct mode that allows you to open up for portraits, where a small depth of field is more flattering, or stop down to a small aperture to obtain maximum depth of field, as is desirable for landscape and macro photography.

This is How Shutter Speed Priority Works: After the shutter speed had been selected and the release pressed, the camera computer will signal that it has calculated an appropriate aperture value for the preselected shutter speed. In the calculation of this aperture it assessed the subject brightness, the film speed, the preselected shutter speed and the aperture setting range of the attached lens. This information about largest and smallest possible aperture values of the lens is conveyed to the camera computer by the appropriate data contacts from the lens CPU. When the release is fully pressed the camera computer activates the diaphragm lever via an electromagnet and closes the aperture to the calculated value. After the mirror has been folded away and the shutter blinds have been opened, the film is exposed at the preselected shutter speed.

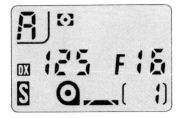

LCD panel information for
aperture priority mode.

Image Creation with Aperture Priority Mode

In aperture priority mode the camera will choose a suitable shutter speed to go with the photographer's preselected aperture. Regardless of what focal length you are using, whether your subject is a landscape, a portrait, architecture or a macro shot, aperture priority is the ideal exposure mode for a wide range of subjects. However, in contrast to the program mode, the aperture priority mode requires a little skill from the photographer.

Using Aperture Priority Mode: Load the film, and select **A** via the **MODE** button and input dial. The AF mode may be chosen according to the subject, either **S** or **C**. Now you can point at the subject, lightly press the shutter release and select the required aperture value on the lens aperture ring. Now the selected aperture value and the calculated shutter speed are displayed in the viewfinder display and also in the LCD panel. Should you wish to change your mind about the selected aperture value, simply turn the aperture ring. The newly selected aperture value will appear and the camera will automatically recalculate a suitable shutter speed.

As long as no warnings appear in the viewfinder, you are free to select any available aperture value to suit your intentions and the subject.

Incorrect exposures are practically impossible as you will be immediately warned by the appropriate displays in the viewfinder:

○ If **HI** appears, instead of the shutter speed (and the audible signal sounds), then the subject is too bright and the measuring and setting range of the F-801 is exceeded. Overexposure is likely. The subject is too bright for the film speed, the preselected aperture value, and the shortest possible shutter speed of 1/8000 sec. In this case you have to select a smaller aperture (larger aperture number). By how much the aperture has to be changed can be read off the analog display. If even the smallest possible aperture value is not small enough, then you will have to use a neutral density filter, or accept overexposure. If you are using a

colour print film, 1 to 2 stops overexposure should not ruin your pictures.

○ If **LO** appears instead of the aperture value (and the audible signal sounds), then this indicates underexposure. This means that the subject is too poorly lit for the film and the preselected aperture, even with the slowest controllable shutter speed. In this case you have to select a larger aperture. By how much the aperture has to be changed can be read off the analog display. Another possibility is to use flash.

○ The danger of underexposure is rare in aperture priority mode. After all, the camera can automatically select shutter speeds of up to 30 seconds. This should produce sufficient exposure levels even at f/2.8 for subjects lit only by candlelight. The real danger is camera shake but the audible signal will warn you of this from speeds of 1/30 sec. and slower.

○ If you are using a conventional lens with mechanical aperture value transfer, but without integrated microprocessor, then — — will be displayed instead of the aperture value because the camera will lack the necessary data for lens speed and actual aperture. This means that as the F-801 is no longer able to use the matrix metering, it automatically changes over to centre-weighted average metering. The aperture priority mode, however, remains active and functions properly. One disadvantage; the selected aperture value can no longer be read off the viewfinder display but has to be checked on the aperture ring.

○ For lenses without any kind of aperture transfer, such as adapters, bellows, slide duplicators, special lenses, etc., the display is also — — instead of the aperture value. Again, the F-801 will change automatically to working aperture mode.

Aperture Priority for Portraits, Architecture and Landscapes: It makes no difference to the exposure level if you select f/4 or f/16 in aperture priority mode. If your camera selects a shutter speed of 1/1000 sec. for f/4, it will, under the same circumstances, select a shutter speed of 1/60 sec. for f/16. The amount of light and therefore the exposure level will be the same in both cases. Apart from the relatively long exposure times which could result in camera shake, and the failure of the

reciprocity law, any time/aperture combination producing an equivalent exposure level is as good as any other. This argument applies only to exposure level. Whether you want to produce a portrait against a sharp background or prefer a blurred background will determine whether the preselected aperture should be large or small. The decision as to which aperture expresses your intentions best is yours.

The optimum aperture depends on the subject and how you wish to treat it. Your ideas of how to present a scene can be totally subjective. If you wish to produce very sharp images, as for example in architectural photography, where every detail needs to be clearly reproduced, then you will have to work with the aperture which produces the best results of the lens in use. Lens aberrations are an optical reality; they may be corrected but can never be removed completely. Theory says that, generally speaking, the performance of a lens is worse when the aperture is fully open because of spherical and chromatic aberrations, astigmatism, etc. Stopping down to the medium aperture values will produce the best reproduction results. If you stop down even further then there will again be a decline in the image quality due to increasing diffraction effects. Practical application and many lens tests have shown that optimum performance lies between f/5.6 and f/11. Therefore an aperture of f/8 or f/8-11 must be considered the best if you are after fine details across the whole image.

Apart from definition, the aperture setting plays a major role in determining the depth of field. You may already know that it is impossible to represent a spatial subject uniformly sharp from a close distance to infinity. Only a few objects are two-dimensional, and most contain spatial elements, so only a certain range of their depth can be represented in sharp focus. From the camera's viewpoint the depth of field is the least to the greatest distance within which the object is represented in acceptably sharp focus.

You should never rely on your own visual impressions when determining the depth of field of a shot. Focusing in the human eye is performed by the visual centre in the brain and is always adjusted to the area or point on which you are concentrating. As this is done without you realising it, you get the impression that everything you see is always in perfect focus. When looking

through your reflex camera, however, you are focusing on a certain point in the viewfinder and the depth of field comprises a limited range in front of, and behind, your focusing point. How great this range is depends on the distance of your subject, on the aperture and on the focal length of your lens.

Depth of Field Made to Measure: A general rule to remember is: long distance, small aperture and short focal length result in great depth of field. It will prove helpful if you can remember a few general values for guidance. Using a lens with a focal length of 50mm and f/8, focused on a subject 0.5m away, the depth of field will be 0.49m to 0.54m. If you focus on a subject at 3m, the depth of field will be from 2.2m to 5.2m. When focusing on a subject at 20m distance, the depth of field will stretch from 6m to infinity. If you focus the 50mm lens on infinity when using an aperture of f/8, the depth of field will extend from about 9m to infinity. These examples show clearly that the shorter the distance the smaller the depth of field. In addition, you have to consider that it will extend further behind the point focused on than in front of it. For medium focusing distance, and disregarding macro photography, the depth of field will extend twice as far beyond the focused plane than towards the camera, or in other words: one-third in front and two-thirds behind the focused plane.

Now if the focal length and focusing distance are fixed, the depth of field may be varied by changing the aperture. In the case of the 50mm lens, focusing on a subject at 3m distance from the camera with an aperture of f/1.2, the depth of field will be from 2.88m to 3.14m. If an aperture of f/5.6 is chosen, the depth of field is increased from 2.5m to 3.7m, and if the aperture is f/22, the depth of field is even greater, from 1.6m to 15m. As you can see, the depth of field increases with smaller apertures. For a distance setting of 5m the depth of field with an aperture of f/16 will be from 2.6m to infinity, and with an aperture of f/22 from 2m to infinity. You should make use of these facts.

If your point of focus is determined by image framing and camera position you can decide the depth of field by choosing a larger or smaller aperture. If you take architectural shots where every detail is important, stop down to the smaller apertures

but in portrait photography, where a detailed background is only distracting, select the large apertures to concentrate solely on the essentials.

The depth of field also depends on the focal length of the lens. The often-quoted rule that shorter focal lengths produce greater depth of field is only true if we assume a fixed camera position for the shot. Let's take, for example, a focusing distance of 4m and an aperture of f/8. With a 16mm lens the depth of field will stretch from 0.8m to infinity. With a 28mm lens, it ranges from 1.8m to infinity, but if we take a 50mm lens, the range is reduced from 2.9m to 8m. As we have used the same camera location in our example, i.e. the same distance to the subject, we find that with increasing focal length the reproduction scale becomes larger. This in turn means that the depth of field of a 16mm lens is considerably greater but the subject is represented as much smaller.

Now if we photograph the same object, using lenses with different focal lengths and with different camera positions, in such a way that for each focal length the subject is represented at the same reproduction scale, then we will have to move much closer to the subject with the wide-angle lens to obtain the same scale with a standard and even more so with a telephoto lens. The depth of field in the wide-angle shot will shrink cancelling the original advantage. The rule of thumb of the gain in depth of field for the shorter focal lengths only applies therefore when we compare equal shooting distances. For equal reproduction ratios, the gain in depth of field is more or less lost except at large reproduction ratios e.g. 1:20 and more.

To summarize the different rules of depth of field for practical application:

○ The greatest possible depth of field is obtained by exact focusing on the important feature in the subject and by stopping down the aperture to a small opening. If you are using the autofocus then the important subject detail should be kept within the autofocus metering field.

○ If you wish to show only a certain part of your image in sharp focus, then you have to focus precisely on the required distance and select a relatively large aperture.

○ If only the foreground up to the important feature is wanted sharply focused, then you have to move the point of focus

closer to the camera, stopping down just enough so that your important feature is only just sharp. This means you use the autofocus to focus on a subject detail closer to the camera, store the focus setting, realign the framing and then release the shutter.

○ If the foreground needs to be somewhat out of focus and the important feature is in the background, then you have to relocate the point of focus just beyond the required feature, and stop down as much as is necessary to bring it just into focus.

Depth of field diagrams or tables are an excellent aid if you are using depth of field as the important aspect in your image creation. Such tables are supplied by Nikon with all their lenses. You can read off the distance range within which a subject is in acceptably sharp focus for the various focal lengths. It is a good idea to browse through them to get a better idea of the depth of field until you develop a feeling for this aspect of photography.

Available Light Photography: The F-801 is suitable for lengthy exposures in practically all the exposure modes. In my experience, however, the aperture priority mode is the most suitable. The program mode is not suitable as you have to take an active part in producing the shot. In any case you would be working within the range which enters the aperture priority mode, as you have to open the aperture wide under low lighting conditions and the exposure has to be controlled by the shutter speed. When using aperture priority mode you are still free to make your choice, even in dimly-lit conditions. Under certain circumstances, if you are taking stationary subjects, it could be advantageous to stop down again to increase depth of field. One also has to consider that certain optical errors are particularly noticeable with wide open apertures.

The automatically-controlled long exposure range of the F-801 in all the exposure modes, depending on film speed, extends to 30 seconds. This is generally sufficient for most night shots.

What films are best for available light photography? To answer this question one has to decide where you are going to shoot and how much light is available. For lengthy exposures, whether at night in the open air, in a dark cathedral, or (if

permitted) in a museum, I would recommend an ISO 400 daylight film. This should allow exposure times of $\frac{1}{30}$ sec. and you can be reasonably sure of sharp pictures if you can support your camera. This film speed is definitely preferable to an ISO 100 film and $\frac{1}{8}$ sec. which makes hand-held shots quite impossible. Personally I wouldn't use ISO 1600 or even 3200 film except as the only possibility for hand-held shots.

The same considerations apply to taking photographs in a theatre or at concerts (if permitted). Often it is quite possible to get a successful snapshot with a reasonably fast film. The ISO 640 artificial light film by Scotch may be suitable for situations lit solely by tungsten light. This film has been considerably improved in recent years and offers excellent quality for this speed.

For real night shots in the open air where you have to use a tripod in any case, I prefer to use an ISO 100 film, because of its better sharpness, graininess and colour rendering.

Whenever you are working with a tripod, or are supporting the camera in some other way, you should always use the self-timer for long exposures. This prevents camera shake when pressing the shutter release. Of course the electrical Remote Cord MC-12A is also suitable, but don't forget to use the eyepiece cover DK-8 which is provided. If your eye is not covering the eyepiece light could enter from behind into the viewfinder and distort the exposure readings.

Long exposures would not be any problem if the reciprocity effect for daylight colour film did not make itself felt from about $\frac{1}{10}$ sec. In other words, the effective film speed diminishes with long exposure times. In this case you will have to effect some exposure compensations. With the F-801 you will not have to worry about this effect for exposure times up to 2 sec., because the matrix metering already allows for a certain amount of overexposure in poorly-lit subjects. For exposure times in excess of 2 sec. you will have to make some compensation. The actual compensation will depend on the type and make of the film used and on the level of exposure time. You could take your own test series or you can ask for a data sheet from the film manufacturer.

In cases where an exposure time of 30 seconds is insufficient, or if you do not want to rely on the automatic exposure control,

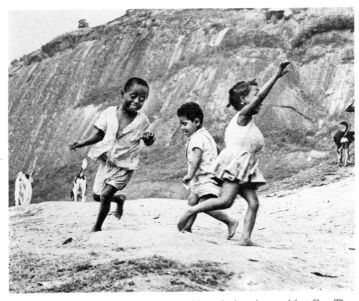

Children at play in Rio de Janeiro; taken with a telephoto lens and fast film. The slight movement blur is an essential feature of this picture.

Photo: Rudolf Dietrich

Page 87:
New York, New York..... the top view is Central Park, the use of shallow depth of field producing an almost impressionist effect. The skyline below should encourage you to take your camera out in bad weather.
Photos: Vanessa Christmann.

Page 88:
Available-light photography (here Dubrovnik at night) is no problem for the F-801 with long exposure times. Both shots were taken at f/5.6 and about 2 secs. In the top picture the remaining bluish light together with the yellow tungsten light produce an attractive effect. Below, the park is illuminated by green lights.
Photos: Michael Huber

Page 89:
Precise stroboscopic shots are possible with the Nikon flashgun SB-24. Look out for ambient light and busy backgrounds when taking such shots.
Photo: Michael Huber

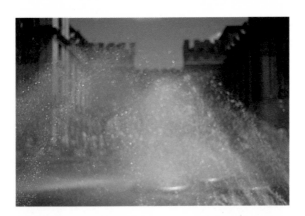

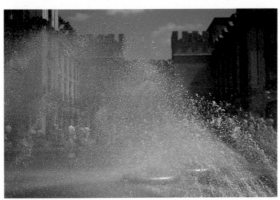

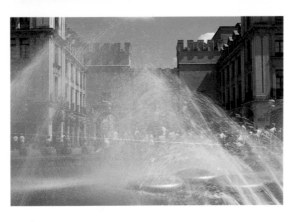

you can change over to manual exposure.

In manual setting the shutter speed sequence includes the **B** setting. This shutter speed setting keeps the shutter open as long as the release is kept pressed. The electric Remote Cord MC-12A is a useful accessory for this shooting mode. The **B** stands for 'bulb'. In reality the initial 'B' stems from the very origins of photography when short exposure times were still some seconds long and photography was not known in Japan at all. The release used in those days was by pneumatic pressure on a rubber ball. As long as this ball was kept pressed, the shutter remained open. This method gave rise to the term 'bulb' and the initial 'B'.

The MF-21 Multi-Control Back is very useful for long exposures. It allows the programming of exposure times from 1 sec. to 99 h 59 min 59 sec. This accessory could be useful for research purposes in the laboratory.

Limits of Aperture Priority Mode: This mode of the F-801 is unsuitable whenever a precisely defined shutter speed is important for the subject in question. If the danger lies in camera shake, then the preselection of a suitable shutter speed is important and you should choose shutter speed priority. If you take people at sport or play, you can capture your subjects quickly and creatively by preselecting a shutter speed that will either freeze the movement or allow its speed to be expressed by a precisely determined movement-blurred effect.

To freeze a movement or to show it speed-blurred with large or narrow depth of field, there are no problems to do it all with the F-801. These photographs of the Stachus in Munich were taken with a 50mm lens focusing on about 4 metres. The top picture was taken at f/2.8 and $^1/_{8000}$ sec; the centre picture at f/8 and $^1/_{1000}$ sec; the bottom picture at f/32 and $^1/_{60}$ sec.　　　　　　　　　　　　　　　*Photos: Michael Huber*

For Special Circumstances: Working Aperture Mode:
When the F-801 is not provided with either mechanical or electronic information about the lens speed and actual aperture value of the lens, then it will always automatically change over from any other exposure mode to working aperture mode. This is the exposure mode for use with adaptors, intermediate rings, bellows, slide copiers, etc.

The working aperture mode is an aperture priority, in which the light entering through the lens is measured. The exactness of light metering is in no way adversely affected. However, matrix metering is no longer possible and the F-801 uses centre-weighted metering.

Let's assume you are using the F-801 with a 400mm, f/5.6 telephoto lens via the so-called T-adapter. To focus, you have to open up the aperture completely to the largest available opening of (in this case) f/5.6. You can even use the AF focus-assist facility as this lens is fast enough. Before you release you

A fast film, at least ISO 400, a long focal length, and a fast shutter speed, are the ingredients for this picture of a traditional ox-riding event.

Photo: Rudolf Dietrich

have to stop down the aperture to the required value, e.g. f/11. Stopping down is indicated by a darkening of the viewfinder image (contrary to open aperture metering). When you release, the F-801 will now measure the actual exposure level in milliseconds and set the calculated shutter speed.

The disadvantage of using working aperture mode is the reduced ease and speed of handling.

This is How Aperture Priority Works: After you have selected a suitable aperture on the lens aperture ring and the metering system has been activated by pressing the release to first-pressure position, the camera computer will calculate the appropriate shutter speed for the preselected aperture. The F-801 uses open aperture metering and the exposure value is therefore calculated from the electronically-transmitted value set on the lens aperture ring and the lens is not really stopped down to its selected aperture value. The aperture will be stopped down to its actual value, only after the release is pressed. Now the mirror is raised and the shutter blinds open.

In the past there were technical reasons why aperture priority was technically the better mode. For optical reasons, the focal plane shutter has to be immediately in front of the film plane, otherwise it would act as an aperture. For this reason the shutter is always fully integrated into the camera. The shutter is therefore an integral part of the camera and independent of any lens used. The same is not true of the diaphragm which, also for optical reasons, is always as close as possible to the optical centre of the lens. The accuracy of the aperture value, i.e. the agreement between the set value and the actual value, will vary from lens to lens. Then one has to consider any inaccuracies in mechanical transfer. The exactness in exposure of cameras with shutter speed priority was therefore not as good as for cameras with aperture priority (measurement for actual working aperture). The tolerances of modern aperture construction have been greatly improved. The actual state of the aperture is electronically assessed and is therefore a true measurement. This means that in a modern SLR camera practically all the exposure modes work with equal precision.

Principles of Exposure

The appropriate settings of aperture and shutter speed for the given subject brightness and film speed form the basis for correct exposure. This applies equally to manual and automatic exposure. In the automatic modes the photographer need not take much notice of the technical aspects and I have kept my explanations in this respect to the necessary minimum. If we consider manual exposure, then the level of expertise has to be much higher. Now it is not just an advantage, but even a necessity, to know the relationships between exposure, subject brightness, exposure metering, film speed, aperture and shutter speed.

What is Exposure? Many a photographer will have asked himself this question particularly as it is possible to take pictures with an automatic camera without having this knowledge. The basic task of the exposure is quite clear; to set a suitable aperture and shutter speed for the given subject brightness which will be correct for the speed of the film used.

We start with the brightness of the subject, and this in turn is partly dependent on the intensity of the illuminating light source. If we think of outdoor photography we will appreciate that it makes a difference if the subject is in bright sunshine, if it is spring, summer, autumn or winter, what time of day it is, and whether or not it is cloudy. Artificial light sources too are of varying intensity; there is a considerable difference between an ordinary tungsten lamp and a photographic halogen lamp.

The light falling on the subject is reflected. The part that you can observe through the viewfinder is exactly the same as that which exposes the film. The brightness of the image projected onto the film plane depends on how much light is allowed to pass through the lens. This in turn is adjustable by a variable-sized opening in the lens — the iris diaphragm that controls the aperture.

But the subject brightness and aperture value are not the only factors that determine the amount of light available for a photographic exposure. The length of time the light is allowed to act on the film emulsion is the other determining factor. The formula to calculate the exposure is therefore:

exposure = intensity of light x duration of exposure

Film Speed: Subject brightness, aperture value, and shutter speed, result in exposure value but still do not ensure that there will be the correct level of exposure. The photographic effect of the exposure plays an important role, i.e. exposure also depends on the sensitivity of the film to the light. Film sensitivity − the film speed − used to be stated in ASA or DIN values, or as is standard today, in ISO speed numbers. The larger the ISO value, the greater the film speed.

The ISO sequence of film speeds (...12/12° ...25/15° ... 50/18° ... 100/21° ... 200/24° ... 400/27° ... 800/30° ... 1600/33° ... 3200/36° ... 6400/39° ...) is arranged in such a way that each stage represents a doubling or halving of the film speed. Naturally, there are also films with intermediate values, such as the well-known Kodachrome 64, rated as ISO 64/19°.

Aperture and Shutter Speed: Exposures must be comparable and it is essential that they can be easily calculated when taking pictures. The setting values of aperture and shutter speed have therefore to be standardised for all makes of camera.

Practically all modern diaphragms are constructed of tiny blades which are adjustable, forming a larger or smaller circular opening. The larger the aperture opening, the brighter the image that is projected onto the film; the smaller the aperture, the darker the image. Standard aperture values, i.e. size of aperture openings, have been defined to allow a comparison between lenses, regardless of type and focal length. These apertures, or f/numbers, apply to any lens, regardless of whether it is used with a 35mm camera or a medium format camera, whether it is a wide-angle or telephoto lens, or whether it was manufactured by Leitz or by Nikon. The image on the film plane will be equally bright for the same subject brightness and f/number. When we talk about lens speed we mean the amount of light allowed through the lens at its largest possible aperture. A lens with a speed of f/2.8, for example, has a maximum aperture of f/2.8.

An internationally standardised sequence of aperture values was devised to provide a comparable f/number sequence for manual exposure settings. This is a geometric series of light intensities, where each aperture is always half the area of the previous value (... 1.0 . 1.4 . 2.0 . 2.8 . 4.0 . 5.6 . 8.0 . 11 .

16 . 22 . 32 . 45 . 64 . 90 ...). To obtain whole numbers, some of these aperture values are rounded-up or down. It is possible, of course, to calculate in intermediate values.

The other variable for the exposure is the time and this is controlled by the shutter. Depending on the selected shutter speed, light is projected onto the film surface for a longer or shorter time. It makes no difference if we call it exposure time or shutter speed, it means the same. The shutter speed, or exposure time, is also standardised for manual setting by the international shutter speed sequence (... 30sec . 15sec . 8sec . 4sec . 2sec . 1sec . $\frac{1}{2}$sec . $\frac{1}{4}$sec . $\frac{1}{8}$sec . $\frac{1}{15}$sec . $\frac{1}{30}$sec . $\frac{1}{60}$sec . $\frac{1}{125}$sec . $\frac{1}{250}$sec . $\frac{1}{500}$sec . $\frac{1}{1000}$sec . $\frac{1}{2000}$sec . $\frac{1}{4000}$sec . $\frac{1}{8000}$sec ...). Here too, the steps are chosen so that the exposure is multiplied by 2 (or halved) from step to step. Some of the values are rounded up or down to obtain convenient numbers. Intermediate values are also possible.

In conclusion we can say that low subject brightness and slow film speed necessitate large aperture openings and slower shutter speeds. Great subject brightness and fast film speeds require small aperture openings and faster shutter speeds.

Exposure Value: If we consider a fixed subject brightness and a fixed film speed, then there is only one exposure value that will lead to the correct exposure of the film. The exposure value is the measure for the equivalent aperture value and shutter speed combination. A particular exposure level may be produced by opening the aperture and selecting a faster shutter speed, or, alternatively, by stopping down the aperture and selecting a slower shutter speed.. Assuming you expose at $\frac{1}{125}$ sec. with an aperture of f/2.8, or at $\frac{1}{15}$ sec. and f/8, it will make no difference; the exposure, i.e. the effect on the film, will be exactly the same.

It is common practice these days to state the measuring and setting range of the camera in exposure values (EV). the exposure value is nothing more than a standardised measure. This measure is the numerical value of a certain exposure (e.g. 8, 12, 17). Here equivalent means that all combinations of shutter speed and f/number have the same effect with regard to exposure, e.g.:

The following combinations of aperture and shutter speed

correspond to an exposure value of 8 (EV8):

Aperture	32	22	16	11	8	5.6	4	2.8	2	1.4
Shutter Speed (sec.)	4	2	1	$\frac{1}{2}$	$\frac{1}{4}$	$\frac{1}{8}$	$\frac{1}{15}$	$\frac{1}{30}$	$\frac{1}{60}$	$\frac{1}{125}$

The following combinations of aperture and shutter speed correspond to EV12:

Aperture	32	22	16	11	8	5.6	4	2.8	2	1.4
Shutter Speed (sec.)	$\frac{1}{4}$	$\frac{1}{8}$	$\frac{1}{15}$	$\frac{1}{30}$	$\frac{1}{60}$	$\frac{1}{125}$	$\frac{1}{250}$	$\frac{1}{500}$	$\frac{1}{1000}$	$\frac{1}{2000}$

The following combinations of aperture and shutter speed correspond to EV17:

Aperture	32	22	16	11	8	5.6	4
Shutter Speed (sec.)	$\frac{1}{125}$	$\frac{1}{250}$	$\frac{1}{500}$	$\frac{1}{1000}$	$\frac{1}{2000}$	$\frac{1}{4000}$	$\frac{1}{8000}$

The difference of 1 EV corresponds to an exposure difference of either one aperture stop or the doubling or halving of the exposure time.

Subject Brightness – Film Speed – Exposure Value:
What exposure value corresponds to the correct exposure and under what circumstances? The following table is provided to give you some guidelines. It applies to subjects with average reflectivity. The values for photographing in the open apply to direct, natural light in average summer conditions and for average daylight. If the sun is high at midday or if there are deep shadows, the EVs have to be amended by up to two stops:

Film speed (ISO)	50	100	200	400	1000
Shooting conditions	**Exposure values**				
cloudless sky	14	15	16	17	18.25
sunny, but very hazy	13	14	15	16	17.25
white, broken cloud cover	12	13	14	15	16.25
dense, dark cloud cover	10	11	12	13	14.25
interior in tungsten light (250 watts)	4	5	6	7	8.25

Exposure Metering: Only if the camera's electronics know exactly how bright a subject is, will the automatic exposure mode be capable of providing correct exposure? Even if you wish to set the exposure manually, you first have to meter the subject. Therefore the correct sequence is always; measure the subject and then decide on the correct exposure.

The difference between subject metering and incident light metering is that in subject metering we measure the light reflected from the subject, as it is reflected back to the camera. Therefore all exposure meters integrated in cameras work by this method. With this system it makes no difference whether the projected image is measured by a separate sensor in the camera housing or in the light path beam of the lens by TTL metering.

When using incident light metering, you measure the brightness of the light as it falls onto the subject. For this you need a separate hand-held exposure meter. Incident light metering is the most exact method because the measuring result is independent of the reflectivity of the subject. With this system it makes no difference whether it is a pure white subject, reflecting 100% of the light, or a pure black subject, reflecting no light at all, or an average grey subject with 18% reflectivity; the measured exposure will always be the same. Taking a picture based on incident light metering, a black subject will be reproduced purely black, and a white subject will always be shown pure white.

Subject metering through the camera lens is more difficult. For the same illumination brightness it will measure different values, depending on whether it measures a black, a grey or a white subject. For this reason a generally-binding reference value had to be found, the so-called average grey. All meters are calibrated, so that an average grey subject is reproduced as the same average grey on the film. This average grey in photography corresponds to a subject of average reflectance, or more precisely, a subject with an average reflectivity of 18%.

If we photograph a card with a reflectivity of 18% (like the Kodak grey card) across the whole frame, then the exposure measurement system in the camera will measure the reflected light, compare this level of brightness with its internal calibrated standard, and calculate the correct exposure value taking into account the set film speed.

In principle it is not important whether the exposure time is calculated for the preset aperture (aperture priority), whether the aperture is calculated for a preset shutter speed (shutter speed priority), whether an automatically set shutter speed and aperture combination is used (program mode), or whether a manually selected aperture and shutter speed combination is chosen. If the camera works properly it is this exposure value that will reproduce the grey card correctly in a colour print with normal enlargement or as a colour slide when viewed at the correct brightness. You can check this by comparing a colour print with the original grey card. Of course, development of the film must be properly carried out and the correct exposure must be given when printing from the negative. To compare a slide with the grey card is a little more difficult. After all, the reproduction of the slide also depends on the intensity of the projection light. In any case, provided the exposure and processing of the slide film was correct, the colour reproduction of the projected slide must give the impression that the brightness roughly lies halfway between black and white.

In conclusion, whether a uniformly average grey object is lit by a bright or by a dim light does not matter, the camera has to adjust the exposure so that an actual average grey is always reproduced as such.

High Contrast: Unfortunately most subjects are not uniform in brightness. Just think about the example of a back-lit shot. If you take a group of people against a bright sky, then the bright light from the unimportant background will dominate the light measurement and result in a relatively high average brightness for the overall picture. The exposure level calculated by the camera will result in the group of people being represented as silhouettes against the light. To compensate for this incorrect measurement, due to the high contrast, you will have to increase the exposure level by up to two stops. This means that the necessary exposure compensation will depend on how much sky is included and where it is placed in the frame, because of the exposure weighting system used in the camera. Only after this compensation has been applied will the important objects in the picture be correctly represented, i.e. correct in their tone rendering. The blue in the sky will probably no longer be

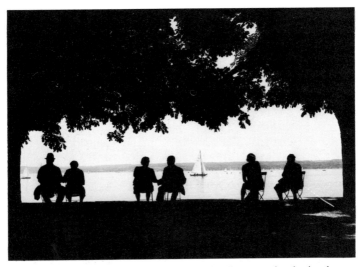

This scene, a Bavarian lake shore, was intentionally exposed and printed as a silhouette. Photo: Rudolf Dietrich

apparent and any white clouds will have merged into the washed-out sky.

When using the F-801 with matrix metering, you need not worry about exposure corrections for contrasty subjects, the camera computer will automatically do this for you.

Extreme Reflectivity: Apart from very contrasty subjects with a large brightness range and where the dark and bright areas are unbalanced, there are other objects with problematic reflectivity. One is where white is on white, and the other is where black is on black. If you photograph a snow-covered landscape you will usually be disappointed; the brilliantly white snow turns out to be dirty grey. The camera's light metering system has interpreted it as an average grey subject, but extremely well-lit, and indicates a very small exposure to compensate. If the snow needs to stay white, it will be necessary to compensate by up to two stops. Even the matrix metering system finds a subject like this difficult. Only if the brightness level is not very high will the matrix metering produce reasonably correct exposures. If you want to be sure, however, you would be better advised to use manual exposure and apply

the appropriate exposure compensation.

It is not only the white-on-white subject but also the black-on-black subject, i.e. the chimney sweep in the coal cellar, that presents problems to the metering system. The camera will interpret this as a badly-lit, average grey subject, and it will be necessary to underexpose by up to two stops to achieve a good black. This too is a situation that the matrix metering system cannot assess correctly. You are therefore well-advised to change over to manual exposure metering when you are presented with difficult subjects as described above.

Centre-Weighted Exposure Metering: Assessing just how wrong the camera's exposure metering system is will depend on its characteristics and on whether you meter the whole subject equally, or assign more importance to the central area, or meter only certain subject areas, as there is integral metering, centre-weighted average metering, and spot-metering. The metering system of the F-801, in manual mode, may be most aptly described as strongly centre-weighted average metering. The central 15% of the picture area is assigned about 75% of the overall metering result, while the remaining 85% contributes only 25% towards it. The contributions towards the metering result decline towards the edges, so the areas on the immediate edges contribute practically nothing. In most cases this is very reasonable, because we usually place unimportant details such as a bright sky at the edge, and if this were metered, it would distort the overall reading. On the other hand, the details placed at the centre of the picture are usually the most important, and need to be correctly exposed. If you are taking a person against a bright sky, then it may easily happen that the sky leads the exposure control to assume that the overall subject is rather bright so that the brightness of the person, the main subject, is not properly considered and the result will be an underexposed picture. Only if the person is exactly in the centre of the picture when the subject is metered will it be correctly exposed first time. For this reason I recommend that the main subject should always be brought into the centre of the viewfinder so that it completely covers the central metering area. The 12mm circle outlined at the centre of the viewfinder is very handy for this purpose, as it defines

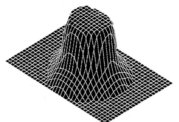 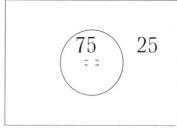

Centre-weighted metering: regardless of the type of exposure metering it is always performed through-the-lens (TTL). The bias in centre-weighted metering is 75:25. This means that the central part of the frame, the area within the circle, contributes about 75% of the total measured result, while the remainder only contributes about 25%.

reasonably well the outline of the 75% centre-weighted metering area. In many ways this metering method is superior to matrix metering. However, if the subject possesses extreme characteristics of reflectance, then even the centre-weighted metering may produce incorrect results.

Matrix Metering and Automatic Exposure Compensation: There are many situations where the automatic exposure control of most cameras is unreliable, because the contrast is too high and the film is no longer capable of accommodating the range of contrast. In other words, the difference between the brightest and the darkest points of the subject is too big so you have to decide to expose either for the light or the dark areas. Without this decision, which the photographer always has to make himself with conventional cameras, the results are either too light or too dark. To cite one of the most well-known subjects in this category, the back-lit shot, the integrated centre-weighted metering will automatically underexpose. The result is a silhouette. To obtain the correct exposure with conventional methods, it is necessary to get close enough so that the main subject fills the frame. How you can achieve this with the F-801 is described in the chapter on manual exposure.

The F-801 will perform the necessary exposure compensations automatically in the matrix metering mode. However, the ambitious amateur photographer should know how this is done in order to be able to assess under what circumstances he may

rely on the automatic exposure compensation of the F-801 or when to take an active part and make his own.

The image projected by the lens falls onto the mirror and from there into the viewfinder prism, where some of the light is projected to the five field sensors. The five field sensors consist, as the name already indicates, of five metering fields. The central metering field corresponds approximately to that of the centre-weighted integral metering area of the conventional single sensor. The four additional sensors cover the areas to the right, left, top and bottom, of the central area, whereby the weighting is always such, that the areas at the edge contribute increasingly less to the metering result.

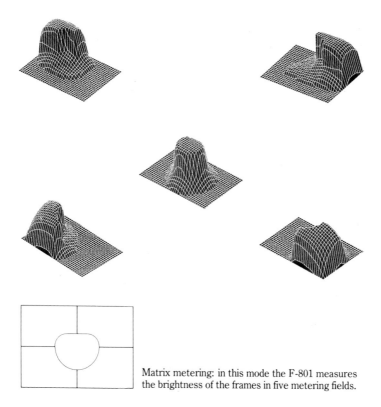

Matrix metering: in this mode the F-801 measures the brightness of the frames in five metering fields.

The matrix metering system of the F-801 assesses the metering results of the five areas as follows:

○ it assesses the average brightness across the five fields, whereby extremely light or dark areas are not considered;

○ it notes the value for the darkest subject field;

○ it notes the value for central field, which corresponds to that of the convential centre-weighted metering area;

○ it notes the value of the brightest field;

○ it ascertains the value − the difference − between the brightest and the darkest field.

The camera computer possesses a matrix (a type of table with five columns) which lists the contrast in five rows and the overall brightness in five columns. The computer is capable of distinguishing between the following five cases:

○ Brightness: extreme dark − dark − average − bright − extremely bright

○ Contrast: very low − low − average − high − extremely high.

This results in five times five, i.e. twenty-five cases, according to which the measured subject may be classified. Depending on which of the five categories the measured value resembles the closest, the computer will control the appropriate exposure. It seems that certain facts have not been clearly explained in the Nikon documentation, and I have therefore set out below the most important cases according to my own research.

○ *Extremely dark subject, contrast very low to high (A)* − Typical are night-shots outside or poorly-lit interiors. Also typical is a situation where a subject is lit by only a few relatively bright points, the remainder of the subject being rather dark. This means that the average brightness is very low but the contrast can be very high. Exposing such a scene based on centre-weighted measurement would most probably lead to very dark or unnaturally light pictures, depending on which part of the subject dominated the central area of the frame during metering. Matrix metering, on the other hand, assesses the average value across the five fields, and this results in natural, well-exposed pictures.

○ *Dark subject, low contrast (B)* − Typical subjects are, for example, landscapes at dusk or poorly-lit interiors. The F-801 automatically exposes centre-weighted and generally

speaking, such subjects are very well exposed, in particular if the main subject is situated at the centre of the frame.

○ *Dark subject, high contrast (C)* − Sunset, well-lit interiors. The F-801 automatically exposes for the average value, to avoid accidental exposure for the light sources in the dark corners. For subjects as these the F-801 generally produces well-exposed pictures.

○ *Low brightness, contrast high to very high (D)* − Typical for bright main subject against a dark background. The F-801 exposes for the bright subject parts.

○ *Brightness low to high, average contrast (E)* − Typical are shots outside in bright daylight and average weather. The F-801 will again expose centre-weighted, and generally the main subject will be very well exposed.

○ *Average brightness, contrast high to very high (F)* − In this case the F-801 assumes that it is dealing with a back-lit subject and it exposes for the dark subject parts. In most cases this assessment is correct and properly exposed pictures will result.

○ *Great brightness, high to very high contrast (G)* − A back-lit subject of, perhaps, bathers at the seaside for example. The F-801 exposes for the average value. With conventional cameras one would have to measure the main subject across the frame or apply additional exposure compensations to produce equally good results as the F-801 is capable of by matrix metering.

○ *Bright, very low to low contrast (H)* − Normal subjects such as street scenes, in bright summery light. The F-801 will expose for the average value across the five metering fields. As the illumination is obviously uniform across the whole frame, the result will be a well-exposed natural looking picture.

○ *Extremely bright, any contrast at all (J)* − Typical for a white sandy beach, a snow-covered field in bright glaring sunlight, or a view directly into the sun. For subjects such as these the F-801 will automatically overexpose for the dark subject parts. One could also say that the matrix metering limits the exposure. It will never expose in excess of what corresponds to EV16⅓ for ISO 100; and EV17⅓ for ISO 200; etc. If the subject under discussion is an extremely brightly lit white-

Automatic exposure compensation: The camera computer assesses the five field metering results according to overall brightness and contrast. The exposure is then selected either for the average, for centre-weighted, for the bright or for the dark subject areas.

	dark	Brightness		bright	
low	A	B	H	H	J
	A	B	H	H	J
Contrast	A	E	E	E	J
	A	D	F	G	J
high	C	D	F	G	J

on-white subject, then this will probably be reproduced satisfactorily.

Even if the F-801 produces fairly well-exposed pictures by matrix metering, you should not rely on it under all circumstances. Extreme subjects will still require additional manual exposure compensation. If you want to be absolutely sure that you are giving the ideal exposure, then I would recommend that you change over to manual exposure mode with centre-weighted metering.

For Perfectionists: Manual Exposure

In exposure mode **M**, combined with centre-weighted metering, you can expose precisely. The only condition is that you measure the subject accurately and that you assess the metering

Matrix metering copes with high contrasts only if the main subject is clearly defined. In a situation like this, the top left picture is underexposed by about one and a half stops. In centre-weighted metering (top right) the result is a little better, but still about one stop underexposed. The exposure (below left) with a format-filling measurement of the face and manual exposure setting would be better underexposed by half a stop. For comparison (below right) an exact exposure, with matrix controlled fill-in flash, but rather boring. *Photos: Michael Huber*

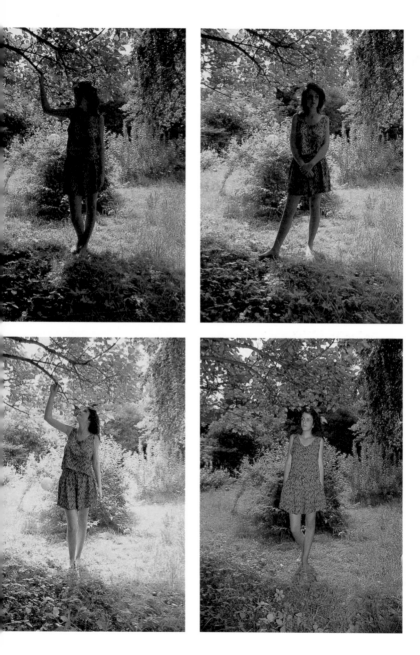

results correctly. The camera's automatic mode cannot perform this task for you. Not only will you have to be familiar with the measuring characteristics of your camera, but you will also have to be aware what exposure compensations are appropriate to the measured results to obtain best the possible exposure for the given subject.

If you are fully versed with the technique of manual exposure, then, in many cases, you will produce much better results than the automatic exposure compensation of any camera.

Press the Mode button and select **M** via the input control dial. Now you can select any suitable aperture via the aperture ring on the lens and the shutter speed is selected by the input control dial. These values are then both displayed in the viewfinder and in the LCD panel.

In manual exposure the metering system is best set to centre-weighted. The matrix metering will still function in manual exposure but in my opinion this is a contradiction. Either you wish to effect automatic exposure, or you want to assess and set exposure yourself, and this is not exactly sensible with automatic exposure corrections.

Point the camera at the subject and lightly press the release. Which aperture/shutter speed combination will result in the correct exposure will be displayed in one-third exposure stops. In manual mode the input control dial display serves as precise exposure indicator. To obtain correct exposure, keep the camera pointed at the main subject and adjust the aperture or the shutter speed, until the bar indicator of the analog display points to zero. As long as the correct aperture/shutter speed combination has not been reached, the display bar will be either in the negative or the positive range.

Let's assume that the shutter speed selected is $\frac{1}{125}$ sec. and the aperture is f/8 when pointing at the main subject, and the bar indicator shows +1. Now you can either keep the aperture at f/8, and turn the shutter speed to $\frac{1}{250}$ sec. or you can keep

The F-801 possesses one of the fastest autofocus systems available. These four pictures were taken from a sequence of eighteen exposures. Shooting data: 200mm focal length lens, normal program mode (f/8 and about $\frac{1}{250}$ sec.), film advance mode **CH** *(about 3,3 frames per second), and autofocus mode* **C**. *All eighteen pictures were perfectly sharp!*

Photos: Michael Huber

LCD panel information for manual
exposure setting.

the shutter speed and instead adjust the aperture to f/11. In any
case, either the shutter speed or the aperture will have to be
adjusted until the display points to zero.

As soon as the correct exposure has been set, you are still
free to adjust the shutter speed and the aperture. You only need
to remember that if you are increasing the shutter speed you
have to open up the aperture, or if you are reducing the shutter
speed the aperture has to be stopped down accordingly. If the
viewfinder display shows, for example, a combination of f/11 and
$\frac{1}{250}$ sec., then you will also produce correct exposure with f/16
and $\frac{1}{125}$ sec. or f/8 and $\frac{1}{500}$ sec.

When measuring the subject, the metering circle at the centre
of the viewfinder may be used to identify the exact area. In
centre-weighted metering mode, the exposure metering of the
F-801, measures, as mentioned previously, this area and this
measurement contributes 75% of the metered values. For very
contrasty subjects for example, for backlit shots, the centre-
weighted metering may not be adequate. In this case you will
have to move closer to the subject, until it fills the whole frame
if possible. As soon as you have taken the measurement in this
way and after setting the exposure values manually, you may
again move away from the subject and select a suitable framing.
The exposure will now always be consistently correct. The
manual exposure setting is therefore a permanent and safe
exposure metering lock.

Ideal for Individual Exposure: How should you take your
light reading and what compensation factors should you apply?
Metering the subject for its average grey, that is, average
brightness, would be the simplest. Whether the subject is
uniformly bright or very contrasty does not matter as long as

110

you find the average area. You simply aim your camera at that area and set the time and aperture to the combination that will result in a balanced indication in the viewfinder. Thereafter you can choose the framing that suits you as the exposure is already stored. If you wish to show this average area a little darker or lighter, than you can make the appropriate compensation.

In many cases it is quite impossible to locate such an average grey value, so what should you do then? Also, you may not be sure what subject area corresponds to what brightness. Good advice such as 'meter those areas of light or shade where there are clearly discernible contrasts' is often less than helpful. There is, however, a very good metering area to be found on one of the most common subjects − the face. In summer, for beach photos, the tonal quality of the average European complexion corresponds closely to the average grey. Therefore, if you are taking a picture against the sun you can meter the face and then recompose your picture, and you will be more often right than wrong. A very pale complexion, which is also supposed to appear pale in the picture, has to be taken with an exposure compensation of $+\frac{2}{3}$ stop. As neither aperture nor shutter speeds can be adjusted by such small amounts it is best to use the exposure compensation facility of the F-801. Simply press the compensation button, which is marked $+/-$, and turn the input control dial to select $+\frac{2}{3}$. After releasing the compensation button the selected value is automatically added to the exposure setting. The exposure compensation symbol $+/-$ in the display reminds you that you have selected a compensation value. If you wish to photograph without any compensation, then you have to press the compensation again and reset it to 0. A dark complexion needs an exposure compensation of up to − $\frac{2}{3}$, to give a natural representation.

In many cases the use of a grey card, generally available from photographic dealers, is very useful. You put this card, which has a reflectance of 18%, within the subject field and you then have the ideal metering area. However, it could be that your subject is not lit very uniformly, partly lying in very dark shade while the rest might be in bright sunlight. Under such circumstances you have to place the grey card within that section of your subject which contains the important detail. If you want to represent average grey a little lighter or a little

darker, then you will have to make the appropriate compensations.

If your main subject is black, and you do not want it to be represented as an average grey, then you will be best advised to use manual mode and not rely on the exposure evaluation of the matrix metering system. You simply meter the black area and use the resulting value with a compensation of −2 stops, the black will then be shown black in your picture. In the same way, you will have to make compensations for objects which are mainly white in your photograph. As a rule, in this case you can use a correcting factor of up to +2 stops. Of course it is possible to work without exposure compensations for mainly white or mainly dark subjects if you are using a grey card in front of the subject.

Only for the Experts: As mentioned previously, the manual exposure setting on the F-801 should be used only if you are sure you will achieve a better result than the electronic control.

Red Square in Moscow, well placed in the frame, with the three figures in overcoats setting off the marble splendour. Photo: Rudolf Dietrich

Don't fiddle around with it unnecessarily, after all, why should you try to work it all out manually, when you have a perfectly good electronic metering and evaluation system at your fingertips that can do it faster and better than you? Only when you are presented with problematical subjects, when you have to meter a precisely-defined area of a subject across the whole viewfinder, be it a face, or a grey card, be it a predominantly black or white subject, will the manual method, together with exposure compensations, definitely produce better results.

Manual Presetting of Exposure: If you are watching a football match and use the procedure: point camera, meter, apply possible exposure compensations, focus, release − you are definitely too slow. In such cases the automatic exposure control with matrix metering would definitely be faster and more reliable. But you won't believe me when I say that, as cumbersome as the manual setting might appear to be, sometimes it can be the best method for fast shots. There are moving subjects which are not particularly suitable for automatic exposure. Just think about footballers in white shorts on a green field. Depending upon how much white is concentrated in the framing you have chosen, or in the centre metering, you will have under- or overexposure, or perhaps you were lucky and the exposure turned out right. For this reason professional photographers always use a preset exposure setting for difficult subjects which are not easy to handle in the automatic mode. To do this you first measure the face of one of the footballers as close up as possible. The values you obtain in this way for the aperture and shutter speed should be correct for the whole game, unless, of course, the lighting conditions change.

Extremely Fast with Manual Presetting: The statement that shooting with autofocus is particularly fast, strictly speaking, is only correct if the main subject is in the centre of the viewfinder, i.e. within the AF metering field. If this is not the case, then you first have to meter the main subject and store the result. Only then can you re-align the camera for the required framing and release. With a little practice this whole process can be quite fast.

Another difficult, if not impossible, situation is when the

subject moves so fast across the frame that the AF system has no chance to focus on it. This is also the reason why professional photographers, who have to earn their living in sports photography, smile condescendingly at this new-fangled facility. They use a different method; prefocus on a distance where the subject is expected to cross. Set an aperture/shutter speed combination that provides sufficient depth of field and at the same time a fast enough shutter speed to capture the subject. Then you only need to press the release when an interesting composition presents itself.

With this method the shot can be taken as quickly as it takes you to decide when to press the release.

This trick is quite easily applied with the F-801. You will need to use an AF lens of the right focal length, e.g. the AF 70-210mm, f/4-5.6 Zoom, and perhaps an ISO 400 or even an ISO 1000 film. Set the camera in manual exposure mode **M** and select a suitable aperture and shutter speed. Now turn the manual focusing ring on the lens to focus on a distance where you are expecting an event to take place that you want to photograph. Now you are ready to release the shutter at any time. If the event takes place at the anticipated location, you can release immediately and the picture will almost always be in sharp focus. As you have used a fast film, you should be able to use a small enough aperture to give you sufficient depth of field. In addition, you could allow the focus-assist facility of the F-801 to provide the extra help in the decision of when to release the shutter. Look through the viewfinder and, if the event takes place in the centre of the viewfinder, the in-focus symbol will light up to indicate that it is in sharp focus. If you release now, you can be absolutely sure that the picture will be sharp. As you can see, manual presetting in combination with the focus-assist facility is the fastest method. In automatic focusing, the focusing metering indication is exceedingly fast. What takes a fraction of a second is the motorised focusing of the lens. You need not wait for this with the method described; just allow the moving subject to come into focus, at which point you release the shutter. This trick corresponds to the previously-described "focusing trap with manual presetting", only here it has been combined with manual exposure setting.

Everything you Need to Know about Flash Photography

Perfect Flash Photography

And who wouldn't want that? But, leaving studio flash photography aside, most flash pictures are anything but perfect. Luckily, this seems to be a thing of the past. In recent years Nikon have managed to make considerable improvements in camera-controlled flash synchronisation and in the technology of flashguns. When assessing my own photographs made with the F-801 and the SB-24 flashgun I often had to check twice, to see whether a certain shot was taken with or without flash.

Four Flash Modes for your Choice: If you are using one of the modern Nikon system flashguns with the F-801, then this has to be set to flash mode **TTL**. You can then select either matrix or centre-weighted flash in any of the exposure modes.

If you have set the F-801 to matrix metering, then the matrix-controlled flash will consider, in fill-in situations, the brightness of the background and surrounding area based on the exposure metering while pressing the release. Even at night, when the flash is the main source of illumination, it still automatically considers the ambient light. When the flash is triggered, the illumination of the foreground is further measured by conventional TTL flash metering. In this way the fore-and background will always be balanced.

If the F-801 is set to centre-weighted metering, then it will work in conventional TTL flash control with centre-weighted measured flash. Again, the background and the remaining light will be automatically considered, but only on the basis of the centre-weighted exposure metering before releasing the shutter. In addition to flash control by the TTL metering, the F-801 will always apply an exposure correction of $-2/3$ EV for fill-in flash, when the exposure metering reports brightness equivalent to daylight. In this way the main subject is not excessively illuminated by the flash.

Your first comment might be: "How Sweet!" But this picture was not meant to romanticise poverty. It simply shows that the most important thing for this young Bolivian Indian is his pet goat.　　　　　　　　Photo: Rudolf Dietrich

As an improvement to previous Nikon cameras and flashguns the F-801 used with the Nikon flashgun SB-24 offers the possibility of automatic flash control in manual exposure setting. The Nikon system flash SB-24 even offers two more flash modes: matrix controlled flash/TTL-M (original Nikon description Matrix controlled TTL flash) and centre-weighted flash/ TTL-M. The descriptions introduced by Nikon are a little confusing, as all automatic flash modes work with TTL flash metering!

Matrix controlled flash/TTL-M means that you have to use the F-801 in matrix metering mode and the SB-24 in flash mode **TTL-M**. With matrix controlled flash, the flash output may be varied manually between +1 and −3 exposure stops. Contrary to the exposure compensation setting on the camera, compensation on the SB-24 flashgun does not influence the matrix metering as a whole, but only the flash. In this way you may

Flash modes with matrix metering			
Flashgun type	SB-23/22/20/18 SB-15/16B	SB-24	SB-24
Flashgun mode	TTL	TTL	TTL-M
Camera metering mode	Matrix controlled flash	Matrix controlled flash	Matrix controlled with additional manual compensation
Possible camera exposure modes	P, P$_D$, P$_H$ S, A —	P, P$_D$, P$_H$, S, A M	P, P$_D$, P$_H$, S, A M

Flash modes with centre-weighted metering			
Flashgun type	SB-23/22/20/18 SB-15/16B	SB-24	SB-24
Flashgun mode	TTL	TTL	TTL-M
Camera metering mode	Centre-weighted flash	Centre-weighted flash	Centre-weighted with additional manual compensation
Possible camera exposure modes	P, P$_D$, P$_H$ S, A —	P, P$_D$, P$_H$, S, A M	P, P$_D$, P$_H$, S, A M

individually vary the brightness of the background during fill-in flash or at night, without changing the brightness of the background at the same time.

Centre-weighted flash/TTL-M means that the F-801 is used in centre-weighted metering mode and the SB-24 in flash mode **TTL-M**. In normal centre-weighted flash control the TTL flash exposure is automatically compensated by $-2/3$ EV. In this mode you can change the compensation to $+1$ to -3 exposure stops. In this case too, the compensation selectable on the SB-24 does not influence the exposure metering as a whole, but only the flash. In this way you can vary the brightness of the foreground during fill-in flash or at night without having to change the brightness of the background at the same time. In cases where centre-weighted metering of the main subject is particularly suitable, this method may be better than the matrix controlled flash/TTL-M mode.

It is of course also possible to use the F-801 in conventional manual flash mode without any automatic control. Using a Nikon system flash you have to set it to operating mode **M**. Below are two tables showing the possible flash modes with the F-801.

Fill-in Flash – Better than Ever Before: Perfectly filled-in backlit shots every time; that has always been a wish with every photographer, even if flash photography wasn't their strength. Nikon already offers an excellent solution with the F-401. The introduction of the F-801 with all its automatic flash modes makes it possible for the first time to produce perfect fill-in flash in all exposure modes.

If you are photographing a subject in front of a backlit background with the F-801, then the main subject will be rendered considerably brighter than with other cameras because of the matrix metering system. But even the exposure compensations effected by the F-801 may not be sufficient to produce the ideal balance. In many cases the foreground is still not bright enough, or the background is overexposed and completely lacking in detail, and even the colours of the main subject appear rather pale.

You can avoid this problem altogether with the F-801 and fill-in flash. All four flash modes will automatically consider brightness of the ambient light and the background, so that the

main subject is suitably illuminated and the resulting picture gives a balanced impression. Not only will the colours of the foreground be realistically rendered, but the background will be shown in its natural brightness and colour.

The differences of the individual exposure modes in connection with fill-in flash are described in the following sections.

Flash with Program Modes: The program modes are the easiest way to good flash photographs. In the simplest case just select one of the three program variations e.g. **P**, **P$_D$** or **P$_H$**; the exposure metering should be set to matrix and the attached Nikon system flash to **TTL**. Regardless of whether the flash is the only illumination source or is used as fill-in flash, the F-801 automatically selects a suitable aperture and shutter speed and measures the flash output. In this calculation it will consider the brightness of the background, the surroundings and the ambient light, thereby making incorrect exposures practically impossible.

Naturally the F-801 provides all the necessary flash symbols; if the flash symbol illuminates for at least two seconds, then the flashgun is fully charged and ready. When taking fast flash sequences you have to be careful not to release too quickly. It is possible to release the flash immediately after the flash LED illuminates, but it won't be able to supply full output. If the flash symbol flashes a few times after releasing, then this means that the flash was too weak, i.e. the distance to the subject was too great or the film speed too low. You must then expect the picture to be underexposed. In this case the only remedy is to get closer to the subject and try again!

The automatically-selected range for the shutter speed lies between $\frac{1}{60}$ and $\frac{1}{250}$ sec.; the range of the aperture between f/2.8 and f/16 (provided the lens offers these values). The range of the aperture is also dependent on the film speed and may vary.

Largest Possible Aperture Openings for Flash in Program Mode:

ISO	25	50	100	200	400	800	1000
Aperture	2.8	2.8	4	5.6	8	8	8

SB-20: Setting range for TTL flash control in aperture priority							
Film speed (ISO)					Flash range (M) with zoom reflector setting to		
400	200	100	50	25	Wide-angle	Standard	Telephoto
Aperture							
2					2,8—20	3,8—20	4,5—20
2,8	2				2,0—15	2,7—20	3,2—20
4	2,8	2			1,4—11	1,9—15	2,3—18
5,6	4	2,8	2		1,0—7,8	1,3—10	1,6—12
8	5,6	4	2,8	2	0,7—5,5	1,0—7,5	1,2—9,0
11	8	5,6	4	2,8	0,6—3,9	0,7—5,3	0,8—6,3
16	11	8	5,6	4	0,6—2,7	0,6—3,7	0,6—4,5
22	16	11	8	5,6	0,5—1,9	0,6—2,6	0,6—3,2
	22	16	11	8	0,6—1,4	0,6—1,9	0,6—2,2
		22	16	11	0,6—1,0	0,6—1,3	0,6—1,5

SB-22: Setting range for TTL flash control in aperture priority						
Film speed (ISO)					Flash range (M)	
400	200	100	50	25	Standard	with wide-angle diffuser
Aperture						
2					3,2—20	2,2—17
2,8	2				2,2—17	1,6—12
4	2,8	2			1,6—12	1,1—8.8
5,6	4	2,8	2		1,1—8,8	0,8—6,2
8	5,6	4	2,8	2	0,8—6,2	0,6—4,4
11	8	5,6	4	2,8	0,6—4,4	0,6—3,1
16	11	8	5,6	4	0,6—3,1	0,6—2,2
22	16	11	8	5,6	0,6—2,2	0,6—1,5
	22	16	11	8	0,6—1,5	0,6—1,1
		22	16	11	0,6—1,1	0,6—0,7

SB-24: Setting range for TTL flash control in aperture priority								
Film speed (ISO)						Flash range (M) with zoom reflector in setting 2		
800	400	200	100	50	25	Wide-angle	Standard	Telephoto
Aperture								
2	1,4					5,2—20	7,5—20	8,9—20
2,8	2	1,4				3,7—20	5,2—20	6,3—20
4	2,8	2	1,4			2,6—20	3,7—20	4,4—20
5,6	4	2,8	2	1,4		1,8—15	2,6—20	3,2—20
8	5,6	4	2,8	2	1,4	1,3—10	1,8—14	2,3—17
11	8	5,6	4	2,8	2	1,0—7,5	1,3—10	1,6—12
16	11	8	5,6	4	2,8	0,7—5,3	1,0—7,4	1,1—8,8
22	16	11	8	5,6	4	0,6—3,7	0,7—5,2	0,8—6,2
32	22	16	11	8	5,6	0,6—2,6	0,6—3,7	0,6—4,4
	32	22	16	11	8	0,6—1,8	0,6—2,6	0,6—3,1
		32	22	16	11	0,6—1,3	0,6—1,8	0,6—2,2
			32	22	16	0,6—0,9	0,6—1,3	0,6—1,5

If the attached system flash unit is a SB-24 then you can change the flash mode to **TTL-M**; now it is possible to effect additional compensations to the flash output. In principle you are also able to use centre-weighted flash mode in all the program modes, whether this makes any sense, is another question.

If depth of field is a consideration in your image creation, then you should use the flash in connection with aperture priority mode. If the background has to be brighter or darker for fill-in flash, then manual exposure is the best mode to use.

Aperture Priority – Flash with Varible Depth of Field:
Setting the F-801 to aperture priority **A** allows manual selection of aperture with flash photography. Both in matrix and centre-weighted metering the shutter speed will be automatically adjusted to between ¹⁄₆₀ to ¹⁄₂₅₀ sec. and the flash is automatically measured after the shutter is released. Both for fill-in flash and also for flash as main illumination the brightness of the background and the illuminated foreground will be well balanced.

The flash control also functions perfectly in aperture priority mode; if the flash symbol illuminates for at least 2 seconds then the flash is ready and fully charged. If the flash symbol blinks several times after release or if it is extinguished altogether, then the flash was too weak, i.e. the distance to the subject was too great, the film speed too low, or the selected aperture too small. You have to expect this particular frame to be underexposed. The remedy here is to open up the aperture.

The main advantage of the aperture priority mode over program mode is that the choice of aperture allows the representation of the background to be either sharp or blurred. This depth of field effect can also be used in night photography, bearing in mind how far the flash can reach to illuminate the background.

You could therefore, if you require great depth of field, select a small aperture. Or if you want small depth of field, select a large aperture − always depending on whether you wish to shoot the main subject against a sharp background with a small aperture or in front of a blurred background with a large aperture.

There is one limitation however, the output of the flash and the film speed, and also the distance of the main subject, allow only a limited range of aperture values for which the flash mode will function perfectly. Details of this are given in the two tables for Nikon system flashguns SB-20, SB-22 and SB-24. The number of permissible aperture values is the largest for average speed film and average subject distance. By the way, it is also possible to use intermediate aperture stops.

Manual plus Flash Modes − Background Brightened to Requirement: It is not always desirable to have the fore- and background more or less equally bright. The opposite could be better; to show the background darker or lighter. This facility is available with the F-801 in manual exposure setting in connection with the flash modes. *Note:* set flash to **TTL** and not to **M**!).

To use fill-in flash with manual exposure mode you should first set the shutter speed to between $\frac{1}{60}$ and $\frac{1}{250}$ sec, then meter the main subject as you would for normal photography and adjust the exposure. Now you can stop down the aperture by up to 2 stops from the calculated value to show the background clearly

darker, or open it up by up to 2 stops to show the background considerably lighter. To find the exact settings, you will have to gain some experience by taking a series of shots before this technique will be perfected.

Shutter speeds in excess of $1/60$ sec. are possible for fill-in flash with manual exposure setting but are not particularly useful. For night shots with available light, slower shutter speeds will produce similar speed-blurred effects.

In Manual exposure mode flash control will be indicated by the flash-ready LED, similar to program and aperture priority mode.

Speed-Blurred Effects with Shutter Speed Priority: In shutter speed priority with the flash modes you can preselect any shutter speed from $1/250$ to 30 sec. For normal flash photography and fill-in flash I can see no advantage in using the shutter speed priority − this is because danger of camera shake and movement blur become a problem for shutter speeds slower than $1/60$ sec.

However, the use of slower shutter speeds can be a useful tool if speed-blurred effects are required. Because of the relatively short flash illumination time a sharp flash image will be superimposed on a second unsharp speed-blurred image, which can produce some interesting effects.

Let's assume the shutter speed has been set at $1/8$ sec. The flash will illuminate the scene for about $1/1000$ sec. and the image recorded on the film will be mainly this flash illuminated image. Then there will be another, fainter image recorded − the scene illuminated by the ambient lighting for the remainder of the $1/8$ sec. If you are photographing a moving subject, then this will be the speed-blurred trace of its movement against the core of the movement frozen by the flash. A similar effect is obtained if the sharp flash image is accompanied by an unsharp outline due to camera movement, i.e. if the exposure time is rather long and you produced camera shake. Most shots such as these are rubbish, but amongst them you may find the odd one which is original and effective. This is a subject area well worth exploring.

As in program and aperture priority, and also for shutter speed priority, the flash control is indicated by the flash LED's.

The Trick with the Second Blind: If you are using the Nikon system flash SB-24 in one of the flash modes, then you can set the flashgun to **REAR**. This will delay the flash synchronisation for the second blind. What this means is that the exposure by the ambient light takes place before the flash is triggered. The difference can only be seen with sufficiently slow shutter speeds, enough ambient light and moving subjects. With conventional flashguns the flash is triggered after the first shutter blind is opened. This results in the movement trace of the subject preceding it. The delay of the flash to synchronise with the second blind causes the movement trace to follow the subject in a natural way.

Obviously, to make use of this facility it will be necessary to set the F-801 to shutter speed priority and use sufficiently slow shutter speeds to make the movement visible. Manual exposure mode may also be suitable. By the way, you will have to sacrifice a few frames and make some experiments before you will be able to produce good shots.

Multiflash: With the F-801 you need not necessarily attach the flashgun to the accessory shoe. Moreover, you can also use several flashguns at the same time, all under automatic flash control. After a little experimentation you can use this to great effect; for instance, to brighten up dark areas in the background, or to simulate against-the-light effects, and much more. As you have fully automatic flash control at your service, you will be assured of perfectly exposed pictures every time! To use the multiflash facility you can use only modern Nikon TTL flashguns such as, for example, the SB-15, SB-16B, SB-20, SB-22, SB-23 and SB-24. Care must also be taken not to overload the camera's electronics by using too many flashguns at any one time.

I was unable to ascertain with certainty whether all flash modes are equally suitable for multiflash mode. I would be a

Architectural shots with the perspective of the extreme wide-angle lens (in both cases 20mm) close to the subject can be quite acceptable. The converging lines emphasise the colossal size of the Roman temple. The picture below speaks for itself. Photos: Wolf Huber

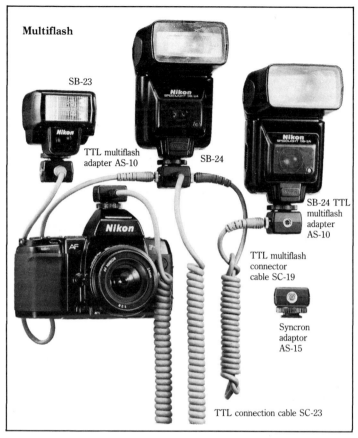

Multiflash

SB-23

TTL multiflash
adapter AS-10

SB-24

Nikon

AF

Nikon

SB-24 TTL
multiflash
adapter
AS-10

TTL multiflash
connector
cable SC-19

Syncron
adaptor
AS-15

TTL connection cable SC-23

little careful when using the matrix controlled flash modes. The centre-weighted metering system would be the best one to use with this set-up.

Another bit of good news is that relatively few accessories

Even such a much photographed subject like the Eiffel Tower can be shown in a new light. *Photos: Wolf Huber*

are needed to make this possible. Apart from the extra flashgun(s) you will need one or more TTL multiflash Adapter AS-10, TTL Remote Cord SC-17, and TTL Multiflash Cord SC-18. To ensure that the simultaneous TTL control of several flashguns functions properly, you have to observe a few simple rules. Firstly, you should only combine Nikon system flashguns. If you use flashguns from different manufacturers, you could encounter exposure problems and, worse still, even damage the camera or the flashguns. Moreover, the flash unit should have approximately equal illumination characteristics and this is not even the case with Nikon system flashguns because of the different guide numbers. Usually in practice this is not critical if you remember the following general rule:-

When using multiflash always use the strongest flashgun as the main source, the weaker ones can be used for filling-in the background, for special effects, and similar purposes.

Principle Limits of Flash Modes: Similar to any other automatic control any flash mode has its limits. Insofar as the exposure metering for the actual flash is concerned, the typical limits of matrix metering or of centre-weighted metering apply. But this has already been described amongst others in the section: "Principles of Exposure".

The fine control of the flash output in TTL metering also has its limitations. After all, it does take a certain time for the electronics of the camera to measure the illumination, to perform the calculation and to issue the signal to the flashgun to switch off.

Danger of overexposure exists with TTL controlled flash if the distance to the subject is relatively small compared with the guide number of the flash and the film speed. To avoid this danger you could use aperture priority mode or manual exposure and stop down the aperture, or you could use a slower film. Another useful trick is the use of the neutral density filter in front of the flashgun. If this is not at hand a piece of transparent paper or some other thin paper (white) could also be used to reduce the effective flash output.

Danger of underexposure occurs if the subject distance is too great and the range of the flashgun is insufficient to illuminate the subject. The greatest possible flash range, which is largest

at the largest aperture, corresponds to the range of the flashgun in manual mode. Even the best flash control can only give the order "full flash output". If this maximum flash output is insufficient, then one has to move closer to the subject, or use a faster film. It may be sufficient to change over to aperture priority and use the largest available aperture.

Subjects with unusual reflectivity could also cause problems in flash photography. The flash mode metering is based on the calibration of a subject of average reflectivity. This calibration to average grey can have serious effects on the measurement and regulation of the flash. For example, if you are photographing dark, poorly reflecting objects, they would be excessively brightened and would therefore look quite unnatural. On the other hand, very bright, strongly reflecting objects, would turn out too dark. The bride in front of a white wall will look too dark and the widow in black inside a dim church will be too light. In cases such as these, when you wish to improve on the automatic mode of the F-801, you have set both the camera and the flash to manual operation.

If the reflectivity of the subject varies strongly across the frame, then you will also not be able to rely fully on the automatic flash. You will have to apply your experience and decide whether you wish to expose for the dark or for the light areas. This too is only possible in manual operation.

I would like to say that the automatic flash modes of the F-801 are very reliable and produce excellent results in the majority of situations and that the Nikon system is one of the best currently available.

Manual Flash only under Exceptional Circumstances!: The argument that one can expose more accurately with manual flash than with any automatic flash control only applies if you also possess the appropriate know-how and by using a rather expensive flash exposure meter. Without a meter you would have to calculate a suitable aperture for the subject distance, the film speed and the guide number of the flash.

However, as the effective flash guide number is often inaccurate and the reflectivity characteristics of the surrounding area also often play a role, it may be necessary to take a series of exposures to ensure perfect flash pictures.

I can imagine only two situations where you would use manual flash with the F-801. Either you possess a powerful manual flashgun and wish to use it on your new camera, or you are faced with a very unusual shooting situation which you can deal with better by manual setting than by TTL control. (See chapter "Limits of Flash Mode"). In the latter case you could also use one of the Nikon system flashguns in manual operation. I shall repeat here the most important points for the use of manual flashguns with the F-801:

○ Use manual exposure mode **M**.
○ Set the shutter speed to $\frac{1}{250}$ sec. or slower
○ Set the operating mode on the flashgun to **M**.
○ Select the appropriate film speed on the scale of your flash unit and read off the appropriate aperture setting for your subject.
○ Read off the aperture value on the scale of the flashgun and set it on the aperture dial of the camera.
○ Now you only need release the shutter.

All this can be done quickly and easily; however, only a few subjects are entirely flat and equidistant from the camera. Most subjects have a certain spatial depth. Just think about the bride and groom's table at a wedding reception. If you select an aperture for the distance (at an angle) to the centre of the table, you may find the bride in the foreground looks pale and washed out, mother-in-law in the middle looks nice in her new hat, but only the nose of the parson at the end of the table glows out of the darkness. Even if you bounce the flash off a white ceiling the results may be unpredictable. So what aperture should you select?

Apart from some extreme subjects such as black on black or white on white automatic flash control is almost always more convenient than manual flash.

Nikon Flashguns

From the large range of Nikon system flashguns, although the SB-16B, SB-18, SB-20, SB-22, SB-23 are fully compatible with the F-801, the SB-24 could be described as tailor-made for it. Other Nikon flashguns can be used with the F-801 but only within certain limits. The guide number in the table refers to films with speed of 100 ISO and a 50mm lens.

Super Flashgun SB-24: This possesses excellent qualities and facilities and is tailor-made for the F-801 and can be used in all four flash modes. It possesses a powerful AF illuminator for automatic focusing in the dark. It also offers conventional manual flash with the highest operational comfort. The selected aperture is displayed on the large illuminated LCD panel, together with the subject distance or flash range. However, the display of the aperture is in whole stops and therefore not absolutely precise. The flash output can be reduced to $\frac{1}{16}$ of the overall power.

Apart from the whole range of flash modes on the F-801 the SB-24 offers flash synchronisation for the second shutter blind (**REAR** mode).

Another unusual feature is the "stroboscope" flash mode. In this mode you can select up to eight flashes at intervals of 1 to $\frac{1}{10}$ sec. In this mode too, the flash range suitable for the selected aperture is displayed on the LCD panel. If the shooting conditions have been suitably arranged − a dark stationery background and very little ambient light − then you should be able to produce special effects by stroboscopic flash without much experimentation.

The automatic motorised zoom of the reflector is another useful aid when using zoom lenses. If the attached lens is one

Flashguns for the F-801 (Selection)							
Flash gun	Guide No.	For focal length with/ without wide- angle diffuser	Batteries No.	Size	Flash rate	Flash No.	AF· Flash
SB-15	25	35/28 mm	4	AA	8 s	160	no
SB-16B	32	85—28 mm Zoom reflector	4	AA	11 s	100	no
SB-20	30	85—28 mm Zoom reflector	4	AA	6 s	160	yes
SB-22	25	35/28	4	AA	4 s	200	yes
SB-23	20	35	4	AA	2 s	400	yes
SB-24	42	85—24 mm Motorised zoom reflector*	4	AA	7 s	100	yes

* When used with lenses with CPU the reflector will automatically adjust for the focal length used.

Flashguns and Accessories

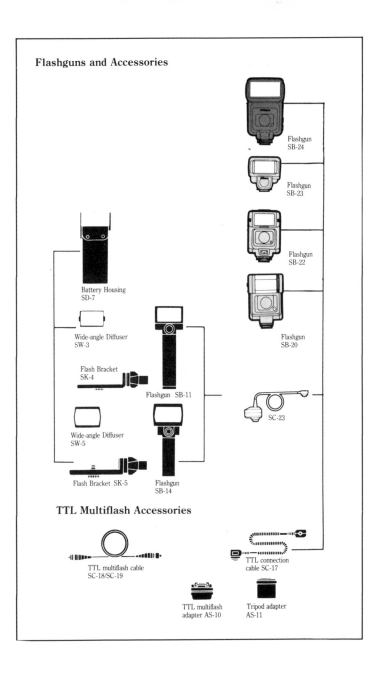

Flashgun
SB-24

Flashgun
SB-23

Flashgun
SB-22

Flashgun
SB-20

Battery Housing
SD-7

Wide-angle Diffuser
SW-3

Flash Bracket
SK-4

Flashgun SB-11

SC-23

Wide-angle Diffuser
SW-5

Flash Bracket SK-5

Flashgun
SB-14

TTL Multiflash Accessories

TTL multiflash cable
SC-18/SC-19

TTL connection
cable SC-17

TTL multiflash
adapter AS-10

Tripod adapter
AS-11

of the modern systems with integrated CPU then the flash reflector will automatically set itself for the relevant focal length.

The illumination characteristic of the SB-24 is another excellent quality. This is particularly uniform and pleasantly soft due to the relatively large, specially structured diffuser screen. The only complaint I have is with respect to colour temperature. The light of the SB-24 is too blue. When photographing with slide film in particular, a skylight filter has to be used. If this is insufficient, attach an 81a filter in front of the first filter.

Autoflash − Only in Emergencies: If you own a camera such as the F-801 with four fully automatic flash modes, then you would be very ill-advised to buy one of these expensive flashguns. It is a different matter if you already own one and only use flash occasionally. With this in mind I can offer you some tips. Push the flash into the accessory shoe and set the shutter speed manually (in manual exposure mode **M**) to $\frac{1}{125}$ sec., read off the aperture value for the film speed from the table on the flashgun and set this value on the aperture dial. Then you still have to check whether the subject distance lies within the range of the flashgun by checking the table on the flashgun or in the manual, then you can release. The metering cell in the computer flash automatically measures the light reflected from the subject and controls the flash illumination time. You should generally obtain quite reasonably exposed pictures with an autoflash. The use of simple manual flashguns is similar; they cost about £10 and in an emergency would be better than no flashgun at all.

Principles of Flash Photography

Thanks to automatic flash modes, the field of flash photography is now open to everyone without the need for complicated calculations and settings. Even so, the dedicated amateur photographer will still be interested to learn all the basic rules. This comes in useful from the start when you are trying to decide what flash outfit to buy. Should you go for the one with a guide number of 32, or is guide number 30 just as good? Would you have known that the flash distance of a flashgun with guide number 32 is only slightly more at f/8 than that of a flashgun with guide number 30?

Flash Synchronisation: The flash may be triggered only after the shutter has been opened across the whole frame (a shutter speed of $\frac{1}{250}$ sec. in the case of the F-801). If the flash is triggered when the shutter is not fully opened i.e. for times faster than $\frac{1}{250}$ sec., with the F-801, then partially-illuminated pictures will be the result.

For the fastest flash synchronisation time of $\frac{1}{250}$ sec. it makes little difference whether the flash is triggered immediately after the shutter is fully opened or only just as the second blind is starting to follow. The time will be the same; the flash triggers exactly when the first shutter blind has reached the other side and the second starts its journey. When we talk of shutter speeds slower than $\frac{1}{250}$ sec. for flash synchronisation with the first shutter blind it means that there will also be some exposure from the ambient light after the flash has been triggered. Synchronisation for the second shutter blind, on the other hand, means that the ambient light will expose the film before the flash is triggered. The difference can be appreciated in flash photographs of moving subjects. Conventional synchronisation for the first shutter blind is typified by the movement trace preceding the subject in an unnatural manner, synchronisation for the second blind will depict the movement trace trailing after the subject in a natural sequence. The F-801 offers this interesting facility of flash triggering for the second shutter blind. However, you will need a suitable flashgun, e.g. the Nikon SB-24 set to **REAR** mode.

Of Guide Numbers, Aperture and Distance: How brightly a subject is illuminated by the flashgun depends in the first place on the output of the flash in watt/seconds (W/s). The other determining factor is the distance from the flashgun to the subject. The law that brightness decreases as the square of the distance applies also to flash photography. If we have a subject at 2m distance from the flash, another at 4m, and a third at 6m, then the subject at 4m distance will only be a quarter as bright as that at 2m, and the one at 6m distance will be only one-ninth as bright as the first. The guide number is the value which takes into account the parameters which have a bearing on the exposure level. The guide number, therefore, depends not only

on film speed, but also on the intensity of the flash. If the distance of the flash from the subject is known, the aperture required may be calculated by knowing the guide number of the flash:

$$\text{Aperture} = \text{Guide number} \div \text{Distance}$$

The distance at which a subject may be correctly illuminated at a given aperture and flash output may be calculated as follows:

$$\text{Distance} = \text{Guide number} \div \text{Aperture}$$

For example, if a subject at 2m distance is illuminated properly by a flashgun with guide number 32 and an aperture setting of f/16 ($32 \div 2$), then the same subject at 4m distance would have to be taken at f/8 ($32 \div 4$) to obtain the correct illumination level. If we look at this the other way round, an aperture setting of f/4 will expose a subject correctly at 8m distance and for f/11 the correct distance is 2.9m.

Most flashguns have a scale from which you can read off the correct range for a given aperture. The guide numbers given always refer to a film speed of ISO 100. Higher speed films result in a higher guide number and therefore a greater range for the flash for a given aperture. This information is also given on the scale of the flashgun. Each doubling of the film speed means a multiplication of the guide number by 1.4. (If the guide number at ISO 100 was, for example, 40, then with a film of ISO 200, the guide number would be 56.) Using the same distance to the subject, you can stop down one aperture by doubling the film speed. This too will be shown on the scale of the flashgun.

In the case of autoflash units and TTL autoflash the guide number represents the maximum output of the flash. If the subject or the distance requires less illumination, the automatic metering will regulate this by reducing the flash duration. Most of us will be glad that autoflash has released us from this cumbersome calculation.

When working with several flashguns, or with a slave unit in multiflash, the combined guide number is also of interest. If the flash illumination is pointed in the same direction and the flashguns are equidistant to the subject, then the guide numbers

of the individual flashguns have to be squared, added and then the square root of the sum has to be calculated:

Combined Guide Number = $\sqrt{(GN_1)^2 + (GN_2)^2 + \ldots + (N_n)^2}$

If several flashguns are used at varying distances, then it would be better to calculate the aperture that has to be set on the lens. The result of the combined effect of the individual valid apertures for each of the flashguns is as follows:

Combined aperture = $\sqrt{(f/no_1)^2 + (f/no_2)^2 + \ldots + (f/no_n)^2}$

Control of Flash Illumination Time: This lies approximately between $\frac{1}{200}$ and $\frac{1}{50,000}$ sec. The idea of automatic flash illumination is to automatically control the flash illumination time depending on the subject and shooting situation. Conventional autoflash units possess an external light sensor that measures the light reflected from the subject during the flash. Let's consider such a flash unit with a guide number of 40, producing its full output at $\frac{1}{500}$ sec. flash illumination time (i.e. for an aperture of f/8 a range of 5 metres). If a lot of light bounces back after triggering the flash, because the main subject is only three metres distant, then the computer simply switches the flash off and reduces the flash illumination time to, let's say, $\frac{1}{1000}$ sec. This method ensures automatically well-exposed pictures. The main drawback of autoflash units, however, is the poor agreement of the angle measured by the flash sensor with the angle of view of the lens. The measuring cell in an autoflash unit usually has a fixed angle of view of about 60°. This means that the measuring angle corresponds to the angle of view of lenses with a focal length of 40-50mm. If you are using a wide-angle lens with a greater angle of view, or a telephoto lens with a considerably smaller angle of view, then the values metered by the flashgun will be more or less wrong. Apart from this, most autoflash units are limited to a certain number of lens stops.

On the other hand, in TTL flash mode the light is metered through the lens (TTL = Through The Lens). After the mirror is folded away, the aperture is stopped down to the working value and after the shutter blinds are fully opened, the flash is

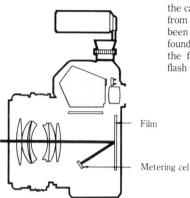

TTL control of flash illumination time: the camera measures the light reflected from the film surface after the flash has been triggered. If the illumination is found to be sufficient then it switches off the flash and reduces the initially-set flash illumination time.

Film

Metering cel

triggered. The meter cell at the bottom of the camera will then measure the light reflected from the film surface during the following shutter opening time and control the flash illumination time according to this measured value. Compared to conventional autoflash units the TTL flash control has the advantage of exact agreement of the angle of view across the entire subject.

In TTL flash control it makes no difference across a relatively wide range what aperture is set on the lens, because the different aperture openings are automatically adjusted by the different automatically-controlled flash illumination times.

But, as with any other automatic setting procedure, this too has its limitations. After all, it does take some time, which is admittedly very short, to measure, calculate, and send the stop signal to the thyristor of the flash unit, and there is also the response time of the thyristor. If the required illumination time is significantly shorter than the response time of the equipment, then this will definitely result in overexposure. Overexposure is bound to occur with TTL controlled flash if the distance between subject and flash is very short, compared with the guide number of the flash unit, or if the selected aperture is too big or the film speed is too fast.

Control of Flash Output: Another method of controlling the flash is by regulating the output level. If the flash mode knows, before triggering the flash, how far the main subject is from the

camera and what aperture is set, then it will automatically regulate the output according to this information. A flash with a guide number 40 used with aperture setting of f/8 and a subject distance of 4 meters would be automatically reduced to an output of guide number 32; for a subject distance of 3 meters, the guide number would be reduced to 24; etc. Nikon are using an approximation of this system, whereby the flash output is varied, in matrix-controlled fill-in flash .

Cybernetic Flash Control: In cybernetic flash control the F-801 combines the advantages of practically all the methods of flash control:

○ Automatic setting of aperture and shutter speed according to exposure metering (matrix or centre-weighted);

○ Presetting of flash output according to exposure metering;

○ Control of flash illumination time after release and triggering of the flash TTL control.

We can say that in cybernetic flash mode the F-801 controls the output of the flash before triggering by setting aperture, shutter speed and flash output, the fine adjustment of flash duration is performed after releasing the shutter by TTL controlled flash illumination time.

In practice this means that the flash mode automatically considers the brightness of the background, surrounding and ambient light, and that it selects by these measured values the aperture and the shutter speed, makes an initial setting of flash output and controls the flash illumination time during the exposure. The cybernetic flash mode of the F-801 may be used in all shooting modes; in program, shutter speed and aperture priority mode and also in manual exposure mode.

Matrix Controlled Flash: The characteristics of matrix controlled program flash can easily be seen from the flash diagram. The cybernetic flash control automatically considers in smooth transition the difference between normal flash and fill-in flash. I have outlined below the most important cases:

○ *General brightness extremely low, any contrast* − The camera computer automatically selects an aperture and shutter speed according to the brightness measured in the central segment. At the same time the flash output is greatly reduced. The flash illumination time is controlled during the selected

shutter speed by measuring the light reflected from the film surface.

○ *Overall brightness very low, any contrast* − The camera computer automatically selects aperture and shutter speed for the darkest area of the frame. The flash output is greatly reduced. The selected shutter speed is controlled during the flash illumination time by the light reflected from the film surface.

○ *Overall brightness low, any contrast* − The camera computer automatically selects an aperture and shutter speed to suit the average brightness of the frame. The flash output is greatly reduced. During the selected shutter opening time the flash illumination time is controlled by measuring the light reflected from the film surface.

○ *Overall brightness low to average, no contrast* − The camera computer automatically selects an aperture and shutter speed appropriate for the brightest area of the frame. The flash output is greatly reduced at the same time. The flash illumination time is controlled during the selected shutter opening time by measuring the reflected light from the film surface.

○ *Overall brightness dark to average, high contrast* − The camera computer automatically selects an aperture and shutter speed appropriate for the brightest area of the frame. The flash output is somewhat reduced. During the selected shutter opening time the flash illumination time is controlled by measuring the reflected light from the film surface.

○ *Overall brightness average, contrast low to average* − The camera computer automatically selects an aperture and shutter speed appropriate for the extremely bright subject areas. The flash output is moderately to greatly reduced. During the selected shutter opening time the flash illumination time is controlled by measuring the light reflected from the film surface.

○ *Overall brightness bright, contrast low* − The camera computer automatically selects an aperture and shutter speed appropriate for the brighter subject areas. The flash output is cut back slightly. During the selected shutter opening time the flash illumination time is controlled by measuring the light reflected from the film surface.

○ *Overall brightness bright, contrast high* — The camera computer automatically selects an aperture and shutter speed appropriate for the average brightness. The flash output is reduced only very slightly. During the selected shutter opening time the flash illumination time is controlled by measuring the light reflected from the film surface.

Through this clever combination of considering the background brightness and the ambient light through the automatic setting of the most suitable aperture and shutter speeds, and subsequent automatic presetting of flash output and additional TTL flash control during the exposure, the F-801 achieves excellent picture quality with flash. To obtain comparable quality with fill-in flash, even a very experienced professional photographer would have to take a number of exposures to achieve the same result.

The centre-weighted flash mode functions similarly to the matrix controlled flash mode, the only difference being that the setting of aperture and shutter speed and also the flash output is based on centre-weighted metering.

The differences in the various flash modes arise because aperture, shutter speed and flash output are preset only in program mode. In shutter speed priority, only the aperture and flash output are preset; in aperture priority only the shutter speed and flash output, and in manual exposure mode only the flash output. The TTL control of the flash illumination time works in all the shooting modes.

The control characteristics of the various exposure functions in flash mode are represented in the appropriate diagrams.

All You Need to Know about Lenses

The Correct Lens for Every Subject

One question is asked repeatedly: "What lenses should I buy to be able to take good pictures?" To such a question I can only answer that cause and effect are the wrong way round. Pictures are taken by the photographer not the lens. My answer in such a case is: "What do you want to photograph and what are your particular aims?" Only when you are clear about your photographic ambitions can you decide on the equipment to serve your creative intentions. Then you can decide, subject to your budget and the characteristics of the various lenses, which are the right ones for your needs.

The Focal Length Determines the Character of the Lens: When considering the effect of different focal length lenses, we have to decide whether we want to take a subject from the same distance with a different scale of reproduction, or from varying distances but with the same scale of reproduction. In the first case, the question: "What do I want to get into the picture?" is the decisive point, in the second case the question is: "How do I get it all into the picture?".

The different angles of view of different focal length lenses determines the characteristic differences in the reproduction scale for the same subject distance. The normal angle of view of a lens is about 50°. To be precise, the standard focal length lens should be 43mm, but a 50mm lens is generaly regarded as the standard focal length for a 35mm camera.

Lenses with a focal length of less than 50mm, e.g. 35mm and 28mm, are considered to be wide-angle. 24mm, 21mm, 18mm and even 16mm are generally referred to as super wide-angle lenses.

Wide-angle pictures, taken from the same viewpoint, i.e. the same distance from the subject, differ from pictures taken with standard lenses in that they contain a lot more, i.e. they have a considerably larger angles of view. This in turn also means a

The speed of the swing is slowest at its highest point. It is sufficient to shoot at $\frac{1}{125}$ sec. To take the shot at the lowest point, you would have to use a shutter speed of at least $\frac{1}{4000}$ or even $\frac{1}{8000}$ sec. to avoid excessive movement blur.

Photo: Rudolf Dietrich

We are surrounded by the most beautiful subjects. Both shots were taken using a 90mm lens and the camera supported on a tripod. When taking transparent subjects against the light it is always a good idea to take a sequence of exposures. In this case it was a matter of luck to produce the perfect shot first time. *Photos: Wolf Huber*

smaller scale of reproduction. The spatial impression is also changed. However, if you enlarge a portion to the size corresponding to that which a normal standard lens would have shown, you will see that the perspective is the same at the same distance from the subject.

If we compare pictures at the same scale of reproduction, then we find that the wide-angle view shows a different perspective from that of the standard lens. The items in the subject closer to the camera are emphasised against a diminished background. We can regard pictures which make use of this characteristic as typical wide-angle views.

By reason of their construction, wide-angle lenses, at full aperture, suffer from a much greater decline in illumination from the centre to the edge than standard lenses do. This in effect increases with decreasing focal length. However, this has been corrected to a large extent in modern lenses. In addition, for the super wide-angle lenses there are also very noticeable distortions which are particularly apparent at the edge of the picture. These two are greater the shorter the focal length of the lens. Certain perspective effects, for example converging lines, are also more noticeable with short focal lengths than with standard lenses.

Lenses with focal lengths of over 55mm are generally called telephoto lenses. Photos taken with these lenses cover a smaller angle of view but the reproduction scale is larger − the subject is apparently drawn closer. In addition, the depth of the subject is compressed by the more distant viewpoint and it looks flatter. Fast telephoto lenses with good reproduction qualities are quite difficult to construct and are therefore quite expensive.

Life Photos with the Standard Lens: I doubt whether you will make a good photo journalist if you always take your pictures from a safe distance with a telephoto or zoom lens. Just look at pictures in a photographic gallery, or at collections of shots from photo-journalists in the 50's and 60's. You will notice that there

The top picture of waves breaking against the shore was taken using a 180mm lens; the one below of the sunset mirrored in the window was taken using a 24mm lens. *Photos: Wolf Huber*

are a lot of pictures which give you the feeling that you are there yourself. To a large extent this is due to the skill of the photographer, but it is also a result of the perspective given by the standard lens which was used then by the majority of photographers for most situations. It was not the fashion simply to zoom in from a distance. Rather, as a famous LIFE reporter said: "You can't get close enough.". This is still true today and it is quite obvious that pictures taken with a standard lens from close to the subject will have maximum impact.

We could say that the standard lens will produce realistic pictures of its own volition, provided, of course, that you are not trying to show something from an unnaturally close, or distant, viewpoint. Then there is another important point; no other focal length has such a high speed as the 50mm lens. The greater speed is not only useful for available light photography; in addition it offers the possibility of sharply reducing the depth of field. As we mentioned previously, the larger the aperture, the smaller the depth of field and the better you can show the subject against a blurred background. Considering the choice of available Nikon AF lenses, then the fixed focal length AF 50mm, f/1.4 must be first choice. It not only offers excellent sharpness, it also has very high speed. The 50mm f/1.8 seems less attractive to me, not because it does not offer excellent quality, but on balance, I would go instead for the standard zoom, the new AF Nikkor 35-70mm, f/2.8. Unfortunately I was unable to test this lens personally. When considering standard zooms the more favourably priced Nikon-compatible Sigma AF 28-70mm, f/3.5-4.5 Zoom is worth considering. The macro fans will perhaps choose the AF Micro 55mm, f/2.8 which offers a very high performance for this focal length.

Wide-Angle for Architecture and Landscape: The normal wide-angle range starts with 35mm. Wide-angle lenses are, as the heading indicates, particularly suited to general view pictures and to emphasise spatial depth. From a given distance the wide-angle lens will include more on your film than the standard lens. The perspective is therefore only seemingly different from that of the standard lens for a given distance. It will change only when you take the wide-angle lens close up to the subject. If you go close enough to your subject to produce

146

The AF Nikkor 50mm,f/1.8 possesses all the excellent characteristics of a standard lens: fast speed, good reproduction quality, compactness and a favourable price.

the same reproduction scale as the standard length, then you will get quite different pictures. Not only will you see more in the picture than with the standard lens, the perspective will appear unduly severe. In a portrait the nose, and especially the tip of the nose, will appear unnaturally large, while the ears, further away from the camera, will look unnaturally small. This presents quite an impossible impression, but you can use the wide-angle lens to great advantage in showing certain impressions. After all, you usually intend to show and emphasise one particular aspect against the rest, the background.

Particularly in landscape photography where you want to draw attention to a characteristic building, a tree, animals or people in a relatively emphasised foreground against a spacious, less emphasised background, a wide-angle lens close to is the only way to do it. Whether you are showing rugged mountains or an endless flat desert, both types of view will be best served by the wide-angle lens. The wider angle of view gives the observer the distinct impression that he is there himself.

Also for interior photography, whether you wish to show a living room or a large hall, the wide-angle lens is ideal. Often you cannot get far enough away from a subject with a standard lens. It is not only this physical restriction that makes this lens less useful, but a view of a room with a wide-angle lens looks more natural. After all, we normally first look around when we enter a room, and the view from a standard lens is almost a technical error as it gives the impression of a sectional view. Of course, this is fine if it was the intention.

So, if you wish to take landscapes, interiors, or architectural

shots then you will need an AF wide-angle lens. At the moment the only one is the Nikon AF 24mm, f/2.8. Even though there are some problems with automatic focusing for the extremely short focal lengths, this would be acceptable, if only the automatic exposure control would function with one of these AF wide-angle lenses (see also chapter "Photographing with Autofocus"). I assume that Nikon will be able to produce a wide-angle lens with integrated microprocessor and a focal length of about 20mm!

Converging Lines – Not Always Desirable: Converging lines are a fault that can also occur with a standard lens if you take the subject from a rather oblique angle. A typical example is the photograph of a high building from close up, when you have to tilt the camera in order to get the whole building into the frame. The lines of the facade seem to converge towards the top of the picture. If such a shot is taken with a wide-angle lens closer to, then the effect is even stronger. One of the simplest remedies for converging lines is; the film plane and the subject plane have to be parallel to each other. In practical applications this may be achieved by relatively large shooting distances and long focal lengths. Furthermore, the photographer has to find a shooting position more or less at the centre point of the subject. In many cases this is only possible by shooting from an upper floor of another building or other high object or by using a special shift lens. On the other hand, you could turn necessity into a virtue and use these defects to produce an imaginative interpretation of reality. The viewer will be given a

AF Nikkor 24mm, f/2.8

AF Nikkor 28mm, f/2.8

148

more powerful impression of the relative size of the building, and therefore you can make a statement from your own subjective impression.

Shift Lenses Control the Perspective: The use of a wide-angle shift lens allows an object to be taken from a short shooting distance and from ground level, without having to put up with converging lines. This is possible due to an optical trick, whereby the lens is shifted parallel to the film plane. Such a mechanically-complicated lens construction is incompatible with autofocus. You can use the conventional Nikon shift lens PC 28mm,f/3.5 or the PC 35mm,f/2.8 with the F-801, with centre-weighted metering and aperture priority or with manual exposure metering.

Correct Exposure with Extreme Wide-Angle Lenses: When taking pictures with a wide-angle lens you have to consider that the light reading could be quite misleading as the wide angle of view is not covered by the standard focal length. This also applies to matrix metering. You could check this by taking the subject in the open, on a tripod and taking two shots, one with the wide-angle, the other with the standard lens. With the standard lens a bright sky will cover only a small area, which only makes a small contribution to the light reading, but with the wide-angle, the sky suddenly fills half your picture. The F-801's matrix metering will compensate for this to a certain extent. Even so, in many cases you will end up with underexposed pictures. In such a situation you should point the camera to largely exclude the sky from the frame, and activate the AEL button. Now you can re-align the camera and release, having excluded the excessively bright sky from the general measurement. In extreme cases you could manually store the metering result by changing over to manual exposure. Now it makes no difference whether the sky covers 20%, or even 80% of the picture, the choice of frame is entirely yours.

The Fisheye View – A New Perspective of Reality: With the Nikkor 18mm,f/3.5 and the 13mm,f/5.6 the distortions at the edge are much more severe than the less extreme wide-angle lenses. Furthermore, the subject will appear noticeably tilted and the other effects of wide-angle perspective, converg-

ing lines and an emphasis on the foreground, will be very much in evidence. Otherwise, both lenses give normal central projection, i.e. the straight lines in the direction of infinity seem to converge towards a common point, as is usual in normal perspective. However, genuine fisheye lenses give spherical perspective. Only the lines which cross the centre point of the picture will be represented as straight lines without any distortion. Any other lines emerging from the edge will not run parallel with the centre point lines, as is the case with other lenses, but will curve round it. The angle of view becomes quite extreme (for example, the Nikkor 6mm, f/2.8 covers 220°!), and you can cram a lot into the picture, but it will be excessively distorted. This may not be so bad for technical photographs, that may be assessed by computer, but whether such pictures are beautiful is doubtful. Some time ago I received an assignment, to show an entire huge hall in one frame, and then I found the fisheye lens very useful. To take photographs of people, on the other hand, is quite impossible. In landscape photography I was also not very successful. One always has to be very careful that no unwanted details get into the picture, there was always something like a telegraph pole in the way or a motorway bridge, and if the sun shone then there it was in the middle of the view, producing the most unwelcome reflections. Personally I have never used a fisheye lens with a 220° angle of view, and I assume it would be very difficult to keep one's ears out of the picture ...

To sum up, for landscape photography I swear by the extreme wide-angle lens, however never less than a 20mm focal length with the well-tried central projection.

Ideal for Portraits – The Short Tele Lenses: The focal lengths between 85mm and 105mm can justly be described as portrait lenses. These focal lengths are ideal for portraits because even if you arrange for the face to fill the frame, you have enough distance between the camera and your model not to crowd in too much. Faces appear particularly natural with these distances. If you tried to take a portrait full frame with a standard lens, you would have to move very close to your subject and the abrupt perspective would be quite apparent. Therefore you would have to move away with a standard lens

and then enlarge the required section from your original frame. If you then compared the result with a portrait taken with a 85mm tele the latter would be the better picture because of better sharpness and freedom from grain. Nikon has at last brought the AF 85mm, f/1.8 onto the market. This is a very fast portrait lens at a relatively favourable price that should meet even professional requirements. In addition there are a number of zoom lenses, offered by Nikon and independent manufacturers (e.g. Sigma) that cover this focal length range.

1:2,8/6mm

1:2,8/8mm

1:2,8/16mm

These fisheye lenses shatter the world of the standard angle of view. The resulting pictures cannot be called beautiful but for scientific purposes these lenses are now indispensable. The diagrams show the difference in construction between a super fisheye and a 16mm wide-angle lens.

Good for Action Photography – The Medium Range Telephoto: Whenever there is something going on and you are not able to move close to the action, then it is handy to have a telephoto lens of up to 200mm at the ready. Under certain circumstances it is quite an advantage to photograph from a distance. You maintain the overall view of busy scenes and pick out the bit that catches your eye. If you now manage to catch the rider falling off his horse, or a super backhand at tennis, or children at play, you are always "spot on" with a telephoto lens. With the AF Nikkor 180mm, f/2.8 IF-ED Nikon offers a lens that not only focuses precisely and quickly, thanks to internal focusing, but it also offers exceptionally high reproduction quality thanks to the use of special glasses. This lens will do justice to your excellent camera and is well worth its, admittedly, high price. A more favourably-priced alternative would be the Nikon AF Zoom 70-210mm, f/4.0-5.6. A little more expensive but of excellent quality is the Sigma AF Zoom 70-210mm, f/3.5-4.5 Apo, which I have had the opportunity to try out myself.

Stalking Your Subject – The Long Lenses: Focal lengths from about 300 to about 600mm belong to the basic equipment of the sports and animal photographer. The really good lenses in this category are heavy, very expensive and not very handy. But the new Nikon AF 300mm, f/4.0 may just about lie within the realms of possibility.

Lightweight Telephoto: at last Nikon have introduced an excellent portrait lens for the AF lens range; the AF 85mm, f/1.8. Its price is also quite acceptable.

A Converter Does Not Replace A Lens: Just as I began to write this book, I received a letter from one of my readers who had bought a very expensive tele-converter which he was unable to use with his F-401. Matters are not quite as serious as this with the F-801, it will still function in aperture priority, but without matrix metering. The purchase of any type of tele-converter is therefore not to be undertaken in haste.

It is worth considering, though, whether the Nikon AF Converter TC-16A could be a useful addition to your camera equipment. The TC-16A multiplies the focal length of the lens used by a factor of 1.6. Provided that the lens has a lens speed of at least f/3.5, you can use any conventional Nikon lens with the bonus that the lens will now focus automatically.

However, there are some qualitative limitations. The reproduction quality of a lens/converter combination in the close range is worse than that of conventional lenses. Flare and ghost images are another problem. This is due to the extra five elements in the optical system, that are introduced by the converter. The lens itself may already have something like 12

Medium Telephoto: the AF 70-210mm, f/4.0-f/5.6 Zoom — affordable even in AF construction.

elements so we should not be surprised when the quality deteriorates.

On the other hand, just because you have decided to buy a wonderful new AF Nikon camera, you need not throw away your old but good Nikon lenses. Viewed in this way, the TC-16A Converter in combination with conventional Nikon lenses may be a very useful solution. To cite from my own experience I have been able to take crisply sharp and brilliant pictures with lenses attached to the TC-16A Converter.

Close-Up and Macro Photography

Strictly speaking, macro photography starts with a reproduction ratio of 1:1. In general terminology most people will accept reproduction ratios from about 1:4 as macro photography. Regardless of how you wish to define it, we are talking about photographs of small to very tiny things, showing them on a large scale.

Still quite easy to handle, the AF 300mm, f/4.0 IF-ED and within the realms of possibility without having to make any concessions to quality.

Whether you photograph coins, stamps, flowers or stones — when taken from the very close range, these objects have a very special attraction. No wonder this type of photography is becoming increasingly popular, even with the amateur.

The most important points in macro photography are good illumination of the subject, exact focusing and as large a depth of field as possible. Imperfections that are irritating in normal photographs, weigh even more heavily in close-ups.

To use the F-801 for macro or close-up photography I would only recommend either aperture priority or manual exposure setting, because it is very important to have full control over the aperture. There is, of course, also the problem of camera shake and therefore the necessity for fast shutter speeds. The use of a tripod is one way of coping with these restrictions. To achieve exact focusing in the close range, the autofocus facility of AF lenses will prove useful.

Supplementary Lenses: A Good Start to Macro Photography: These lenses are the simplest and cheapest way of entering the field of macro photography. They are screwed into the filter thread of your lens and reduce its focal length. You can move closer to the subject and thereby increase the reproduction scale. Depending on lens and focal length you can get down to a reproduction ratio of 1:2 with this arrangement. For the

The 300mm, f/2.8 lens combined with the AF converter TC-16A turns into a fast 500mm lens.

Special Lenses and other Macro Accessories.

Micro Nikkor
105mm, f/2.8

Medical Nikkor
IF 120mm, f/4

Micro Nikkor
200mm, f/4

Nr. 0 Nr. 1 Nr. 2 Nr. 3T Nr. 4T Nr. 5T Nr. 6T

AF Micro Nikkor 55mm, f/2.8

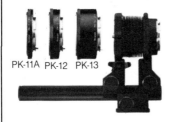

PK-11A PK-12 PK-13

AR-10

PB-6E

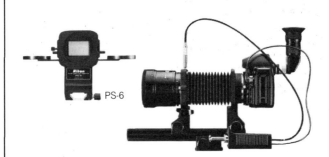

PS-6

52mm filter thread Nikon offers supplementary lenses of +0.7, +1.5 and +3 dioptres. Nikon also offers achromatic supplementary lenses with +1.5 and +2.9 dioptres for the 52mm and the 62mm filter threads and these are particularly good.

If you are using supplementary lenses you have to stop down as much as possible to compensate for the decline in reproduction quality, which is inevitable. Moreover, in macro photography the depth of field is minimal and you will have to stop down for this reason alone. In my experience the AF lenses are quite suitable for macro photography with supplementary lenses. However, the automatic focusing will work only if you manage to find the exact distance range to the subject within which focusing is possible. Or, in other words, the autofocus will work with a supplementary lens only if you could have focused manually in the same distance range. I would suggest, you try first focusing manually, find out within which distance range the subject can be brought into focus, then change over to autofocus. After that, the autofocus will work faster and more precisely then manual focusing.

Ideal for Close-Ups: Macro Lenses: The fastest and most reliable equipment for macro photography is without doubt an appropriate macro lens. Nikon has prefixed their Nikkor lenses in this range with "Micro". These lenses are quite normal but their design is optimised for the close range. The inclusion of floating elements causes the optimum correction to move from infinity to the macro range according to the focusing distance.

At the moment there is only one AF-compatible macro lens available for the F-801: AF Micro 55mm, f/2.8. This is an excellent lens with which you can focus continuously from infinity to 0.23m (corresponding to a reproduction ratio of 1:2). For the macro fan this would not be a bad choice as a standard for the F-801 because it is also perfectly suited for normal photography by reason of its special corrections. The conventional Nikon Macro lenses; the Micro Nikkor 105mm, f/2.8; the 200mm, f/4.0 and the Medical Nikkor 120mm, f/4 are also compatible with the F-801. However, these will have to be used with centre-weighted metering in aperture priority or in manual exposure mode.

In macro photography it is generally advantageous to use

Close-up Equipment

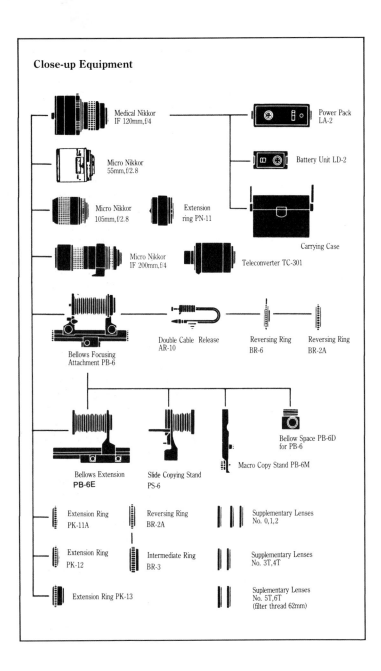

Medical Nikkor
IF 120mm, f/4

Power Pack
LA-2

Micro Nikkor
55mm, f/2.8

Battery Unit LD-2

Micro Nikkor
105mm, f/2.8

Extension
ring PN-11

Carrying Case

Micro Nikkor
IF 200mm, f/4

Teleconverter TC-301

Bellows Focusing
Attachment PB-6

Double Cable Release
AR-10

Reversing Ring
BR-6

Reversing Ring
BR-2A

Bellows Extension
PB-6E

Slide Copying Stand
PS-6

Bellow Space PB-6D
for PB-6

Macro Copy Stand PB-6M

Extension Ring
PK-11A

Reversing Ring
BR-2A

Supplementary Lenses
No. 0,1,2

Extension Ring
PK-12

Intermediate Ring
BR-3

Supplementary Lenses
No. 3T,4T

Extension Ring PK-13

Suplementary Lenses
No. 5T,6T
(filter thread 62mm)

lenses with longer focal lengths. The reason being that you do not have to move so close to the subject to achieve the same reproduction ratio. For a reproduction ratio of 1:1, using a 50mm lens, you will have to move to within 10cm of the subject, with a 100mm lens the distance is already doubled to 20cm. Because of the greater distance to the subject, the danger of causing shadows is much less, and if you are after some small insect you have a better chance to catch it unawares.

Extension Rings – Not Always Suitable: Not all conventional Nikon extension rings are suitable for use with AF lenses. You will have to check the model code, for example, instead of the old PK-11 it is now PK-11A, etc. (please refer to the table). In my opinion, extension rings are rather cumbersome to use and inflexible and it is much more practical to use proper macro lenses or perhaps supplementary lenses. If you are a perfectionist in the field of macro photography then you will choose bellows anyway.

Bellows for the Specialist: These form the most universal equipment in macro photography, as they allow continuous focusing across a wide range. That the AF system does not function with bellows is no problem, as macro photography is the domain of the careful and unhurried perfectionist and not a matter for the quick shot. Bellows are offered by a number of reputable manufacturers, such as, for example: Hama, Rowi and Novoflex. Nikon offer their Model PB-6, which is a particularly robust unit. Focusing rails are also available and allow focusing with absolute precision. In the range of 1:1, or over, the sharpness is best adjusted by varying the distance to the subject and not by adjustment of the bellows. Any good objective may be suitable as a lens, e.g. the EL Nikkor, or the Apo Rodagone (Rodenstock), as these are specially designed for this application. Of course, it is also possible to use the Micro Nikkor lens with the bellows. To trigger the camera shutter and the diaphragm simultaneously, one needs the electro-mechanical Double Cable Release AR-10 for the F-801.

For reproduction ratios of 1:1 and over, macro lenses should be used in reverse position. This means, the lens is inserted into the camera with the front element facing the film. The

reason for this is that the lenses are designed for optimum performance when the distance of subject to lens is greater than the distance of lens to film. To attach the lens in reverse position Nikon offers four reversing rings for the Nikkor lenses.

Slide Duplicating made Easy: A special area of macro photography, which should be of interest to almost any photographer, is the duplication of slides. When sending in slides for competitions this is the only possibility of safeguarding yourself against loss.

I have already discussed the proper illumination for slide duplication in the chapters on flash photography. In this chapter I will discuss what kind of equipment you will need. You will be glad to hear that this is not very expensive. I performed some tests, comparing the simple slide duplicator by Hama, Model 35T, with a special repro-lens costing ten times as much and found that I produced much sharper slides with the Hama. I would like to mention, however, that the lens I used was not a Nikon lens. The only disadvantage with the Hama is, that the reproduction scale is slightly greater than 1:1 and the edges of the original are cropped. If it is important to reproduce the slides exactly to size, then it would be best to use a slide attachment with the bellows. Hama offer such a unit with integrated macro lens. Nikon offer a Slide Copying Adapter PS-6 for use with the Bellows Focusing Attachment PB-6 but then you will still need a macro lens.

To produce good duplicates you will need the special Slide Duplication Film by Kodak which is developed like any other slide film. If you use a normal slide film for duplication the results will be too contrasty.

What Lenses for the F-801?

Nikon have made a big contribution in the last 25 years to the development of optical equipment for photography. The experience and know-how developed by Nikon are utilised in the newest generation AF Nikkor lenses.

Nikon was one of the first manufacturers to successfully optimize their lenses with equal success for both the close and the far ranges. This was a great step forward, because

conventional lenses are generally optimised for infinity only. This means that any errors are minimal when the lenses focused on infinity — the reproduction quality is at its best. By incorporating close-range correction (CRC) Nikon make some of their range suitable for close-up photography. This is achieved by the use of additional moveable optical elements, which compensate to a large extent for certain typical close range errors, such as curvature of field. In most conventional lenses there are two groups of elements which move against each other; the CRC lenses use an additional group of elements between these two. This experience has been utilized in the construction of the Nikon zoom lenses that are offered today in the Nikon AF system range.

Nikon's achievement in the field of special correction for telephoto lenses is quite exceptional. Chromatic aberration plays a role in long focus lenses. Blue, green and red light do not combine to a common focal point which results in colour fringes. These days, all modern telephoto lenses are achromatic, that is, chromatically corrected to a certain extent and actual rainbow fringes are quite rare. But this does not constitute real contour sharpness by a long way; only apochromatic lenses can achieve that. The optical precondition for their construction is the use of special types of glass, ED glasses, which have extremely low dispersion. They either do not disperse the spectral colours, or only in a special way, so that their use in the overall lens construction results in a sum of chromatic aberration of close to zero.

In the matter of focusing Nikon has also been in the forefront. In conventional telephoto lenses, the main groups of elements move against each other, which alters the overall length of the lens quite considerably. If you are handling a very long lens this could be quite difficult and cumbersome. If you are pressed for time you will usually end up with some sort of approximation. Nikon solved this problem by internal focusing (IF). The overall length of the lens remains constant, and focusing is achieved by moving an optical element between the two main groups. Not only can you focus more quickly and accurately with these types of lenses, both manually and by autofocus, they are also lighter and more convenient. Furthermore, this construction can easily be combined with the automatic correction (CRC) which produces an overall improvement in reproduction quality. Nikon

offer the new AF telephoto lenses AF 180mm, f/2.8 and AF 300mm/f2.8 with internal focusing because of the above-mentioned characteristics.

Notwithstanding the above arguments, not all Nikon lenses are automatically the best. At least part of the AF lenses of the first generation could have been better. On the other hand, Nikon is right to offer not only the very best in lens construction. After all, a manufacturer cannot live by serving only the top requirements of the market. There is a very wide market to be satisfied and if there is a demand for 70-200mm zoom lenses, 12cm long and weighing 400g, for example, all at a reasonable price, then the manufacturer will try to meet it.

Light, Short, Fast, Optically Excellent, 35-200mm: This is how many amateurs and even professional photographers want a good lens to be. Unfortunately, this wish is as unrealistic as wishing for a quiet, spacious town penthouse apartment in the centre of a huge park, at only £100 a month rent. If quality is an absolute requirement, then you will soon realise, that you will have to carry around with you a few extra centimetres and a few extra grammes and it will cost you considerably more. However light and handy a mediocre lens may be, it still constitutes unnecessary ballast, and the £50 or £100 that you may have saved have to be set against the £200 that you have spent for an unsatisfactory lens. When buying photographic equipment, one should keep John Ruskin's proverb in mind: "it is an expensive business to spend too little".

Fixed Focal Length or Zoom? If you own a good camera you will also want to buy a few good lenses for it. But which ones, that is the question. "One zoom for everything" is just about the worst advice anyone could give you. To be sure, there are several arguments in favour of the zoom; you need not change the lens during shooting, which is faster and less distracting; you need not carry several lenses around with you; and an all-in-one lens is cheaper than the sum total of several individual focal lengths. But almost all these arguments can be countered. One zoom lens can be so cumbersome and heavy that you might as well leave it at home. If you use a zoom you would not try to get the best viewpoint because you can stand in one position

and just twiddle the controls. Pictures don't get any better in this fashion and as I have pointed out before, the best tip for good pictures is and always has been: "as close as possible to the subject!".

I am not at all convinced that zoom lenses are better value for money. A zoom lens whose reproduction quality is anywhere near that of a fixed focal length lens would cost the earth. The present state of technology is capable of producing a zoom lens, using special types of glass, special lenses, floating elements, and fine precision mechanics, that has the same quality of reproduction as high quality fixed focal length lenses. Even maximum aperture, weight, and overall dimensions need not be much worse. There is only one thing wrong with the argument − nobody would be able to afford such a super zoom. This is the reason why available zoom lenses have much slower speeds and why the optical problems which arise in the construction are still corrected by including extra elements. In this way a fixed focal length lens with nine elements becomes a zoom with fifteen and more. Even if this extra expenditure in elements compensates for the errors, the zoom will never produce better results than a fixed focal length lens. One has to keep in mind that every extra element has two additional air/glass surfaces so however much multi-coating is done, if a lot of elements are used, it will cause the lens to lose contrast and become more susceptible to flare. Even the recent trend towards lighter, faster, and above all, smaller zooms, which is also the case for AF lenses, must be a regressive step from the point of view of optical performance. Don't ever ask for the maximum number of individual elements when you decide on a lens − it does not mean that you are getting value for your money. I suggest you read several magazines where you can usually find comparative lens tests. Between lenses that have been assessed as equally good, personally, I usually select the one with the least number of elements.

In conclusion we can say that every zoom − the same being the case for fixed focal lengths − represents a compromise between range of focal lengths, performance, speed, weight, size and price. Except that the technical effort required is not so extensive with fixed focal length lenses as with zooms and, at least in theory, their price should be more reasonable. Or the

other way round, at the same price the fixed focal length lens will be technically more refined because the basic technical cost for a zoom lens is already that much greater. Another aspect to consider is that modern zooms are produced in bigger production runs than fixed focal length lenses and may therefore be relatively cheaper. But the basic pricing levels vary from manufacturer to manufacturer. An expensive fixed focal length lens from one manufacturer need not necessarily be better than a reasonably priced zoom from another. Don't make the mistake of dismissing either one or the other out of hand. One thing seems certain, for optimum quality at a certain focal length you would be best served with a fixed focal length lens. On the other hand, a zoom lens need not necessarily be good, just because it is expensive.

In conclusion we might say that the assertion that fixed focal length lenses are superfluous these days is just as wrong as saying that zooms are inferior in quality. However, if you are considering a certain focal length for which you require the best possible optical quality, then the fixed focal length lens will serve you better. With this in mind we have to welcome Nikon's decision to introduce, after their initial hesitation, a series of high quality AF fixed focal length lenses.

These cross-sections show the advantages and disadvantages of zoom lenses. Fixed focal length lenses 35mm, f/2.8 (left) and 105mm, f/2.5 (centre) are constructed with 5 elements. The AF 35-70mm, f/2.8 Zoom requires 15 elements and this is the reason for its greater weight and size and, despite the optical sophistication, it is more susceptible to flare and ghost images.

Lenses by Other Manufacturers – A Forbidden Subject?: As far as AF lenses are concerned, the F-801 photographer will probably reach for the Nikon AF lenses. However, Nikon-compatible AF lenses by reputable manufacturers are certainly worth considering. One thing is clear; good quality has its price. Be cautious before you are taken in merely by the price. There are a number of cheap offers about, but as far as I know, some have caused problems when used with the F-801. It is bad enough if the camera does not function properly with a so-called AF-compatible lens but it could damage the camera and that would be much worse.

Nikon, of course, will only furnish a warranty for their own lenses used together with the F-801. That they do not give you any guarantee that other lenses will work perfectly with their own cameras cannot be held against them. Should you eventually decide on a Nikon AF-compatible lens from a reputable manufacturer, then your risk would be minimal if you choose manufacturers such as, for example, Sigma, Tokina and Tamron. Sigma offer six Nikon-compatible AF Zoom lenses, including a 25-70mm, f/3.5-4.5; a very fast 75-200mm, f/3.8 and the optically brilliant 70-210mm, f/3.5-4.5 Apo. If the manufacturer gives you a year's guarantee, then such a purchase would be worth considering. Tokina and Tamron have also announced the introduction of AF lenses, however, their compatibility with the F-801 could not be ascertained at the time this book went to press.

The Ideal Lens Combination: It does not exist! However, there are criteria which should assist you in deciding which lenses would make an outfit to suit your own particular needs. Before you go and buy one or two zoom lenses, you should first consider lens speed, handiness, weight, and price, and compare this to the fixed focal length lenses. I am sure you will come to the conclusion that fixed focal length lenses in the range from 28mm up to 50mm are almost always lighter, faster, and even cheaper, than a good zoom. The AF Nikkor 28mm, f/2.8 weighs only 269g and measures 4.6cm. The new Nikon AF Zoom 28-85mm, f/3.5-4.5, on the other hand, weighs 500g and measures 8.9cm. As you can see, the fixed focal length lens in the wide-angle range is more than a stop faster and much easier to carry. If we now consider the longer focal lengths, around 180mm,

then the fixed focal length lens still has the advantage of being faster, but in respect of handiness and weight the AF Zoom 70-210mmf/4.0 is better than the AF 180mm,f/2.8. In the latter case the optical superiority of this lens is worth considering against the advantage in weight and size!.

My advice is as follows; buy the F-801 together with AF f/1.4 standard lens or with a good AF 35-70mm Zoom. Later, when you know better where your preferences lie, you can complement the standard lens with fixed focal lengths in the wide-angle range or further zoom lenses. How about the AF 24mm lens for landscapes and the AF Zoom 70-210mm as a universal telephoto lens? If you are interested in portrait photography you could choose the AF 85mm,f/1.8. Then there is also the super-telephoto AF 300mm,f/4.0 to be added to the list. Perhaps Sigma will finally produce, as promised, a 400mm,f/5.6 in Nikon AF-compatible construction.

But who says you can't take good pictures with a limited range of lenses? One good quality lens is always worth more than two inferior ones, especially if they are safely tucked away at home!

The very fast AF 35-70mm,f/2.8 Zoom can be justly described as the ideal standard zoom lens, which makes it a perfect partner for the AF 70-210mm Zoom. However, you should also consider whether additional fixed focal length lenses in the telephoto and wide-angle range would be a better solution.

Nikon AF lenses						
Lens	Groups/ elements	Angle of view	Filter thread (mm)	Lens hood	Weight (g)	Diam x length (mm)
Zoom						
3,3 – 4,5/ 24 – 50 mm	9/9	84 – 46°	62	HB-3	375	70,5 × 73,5
3,5 – 4,5/ 28 – 85 mm	11/15	74 – 28°	62	HB-1	540	71 × 89
2,8/ 35 – 70 mm	12/15	62 – 34°	62	HB-1	665	72 × 95
3,3 – 4,5/ 35 – 70mm	7/8	62 – 34°	52	HN-2	275	70,5 × 61
3,5 – 4,5/ 35 – 105 mm	12/16	62 – 32°	52	HB-2	460	69 × 87
3,5 – 4,5/ 35 – 135 mm	12/15	62 – 18°	62	HB-1	630	72 × 109
4,0 – 5,6/ 70 – 210 mm	12/9	34 – 11°	62	HN-24	590	73,5 × 108
ED 2,8/ 80 – 200 mm	11/16	30 – 12°	77	HN-28	1200	85,5 × 176,5
Wide-angle						
2,8/24 mm	9/9	84°	52	HN-1	260	65 × 46
2,8/28 mm	5/5	74°	52	HN-2	195	65 × 39
Telephoto						
1,8/85 mm	6/6	28° 30'	62	HN-23	415	71 × 58,5
2,8/180 mm IF-ED	6/8	13° 40'	72	integrated	750	78,5 × 144
2,8/300 mm IF-ED	6/8	8° 10'	39	integrated	2700	133 × 255
4/300 mm IF-ED	6/8	8° 10'	39	integrated	1330	89 × 211
Standard						
1,4/50 mm	6/7	46°	52	HR-2	255	65 × 42
1,8/50 mm	5/6	46°	52	HR-2	210	65 × 39
Special						
Micro 2,8/55 mm	5/6	43°	62	—	420	74 × 74
AF Tele- converter TC-16A	5/5	—	—	—	150	69 × 30

Conventional Nikon lenses and their compatibility for AF function with the F-801								
Lens	Focusing		Exposure mode				metering method	
	AF	M/E	P	S	A	M	MM	MI
Zoom lenses								
3,5–4,5/28–85 mm		•			•	•		•
3,3–4,5/35–70 mm		•			•	•		•
3,5/35–70 mm		•			•	•		•
3,5–4,5/35–105 mm		•			•	•		•
3,5–4,5/35–135 mm		•			•	•		•
3,5–4,5/35–200 mm		•			•	•		•
4/80–200 mm		•			•	•		•
4,5/50–300 mm ED		•			•	•		•
5,6/100–300 mm		•			•	•		•
4/200–400 mm ED		•			•	•		•
8/180–600 mm ED					•	•		•
Wide-angle lenses								
5,6/13 mm		•			•	•		•
3,5/15 mm	①	•			•	•		•
3,5/18 mm	①	•			•	•		•
2,8/20 mm	①	•			•	•		•
2/24 mm	①	•			•	•		•
2,8/24 mm	①	•			•	•		•
2/28 mm	①	•			•	•		•
2,8/28 mm	①	•			•	•		•
1,4/35 mm	①	•			•	•		•
2/35 mm	①	•			•	•		•
2,8/35 mm	①	•			•	•		•
Standard lenses								
1,2/50 mm	①	•			•	•		•
1,4/50 mm	①	•			•	•		•
1,8/50 mm	①	•			•	•		•
Telephoto lenses								
AF 2,8/80 mm	①	•			•	•		•
1,4/85 mm	①	•			•	•		•
2/85 mm	①	•			•	•		•
1,8/105 mm	①	•			•	•		•
2,5/105 mm	①	•			•	•		•
2/135 mm	①	•			•	•		•
2,8/135 mm	①	•			•	•		•
2,8/180 mm ED	①	•			•	•		•
2/200 mm IF-ED	①	•			•	•		•
AF 3,5/200 mm IF-ED	①	•			•	•		•
4/200 mm		•			•	•		•
2/300 mm IF-ED	①	•			•	•		•
2,8/300 mm IF-ED	①	•			•	•		•

Conventional Nikon lenses and their compatibility for AF function with the F-801								
Lens	Focusing		Exposure mode				metering method	
	AF	M/E	P	S	A	M	MM	MI
4,5/300 mm		●			●	●		●
4,5/300 mm IF-ED		●			●	●		●
2,8/400 mm IF-ED		●			●	●		●
3,5/400 mm IF-ED		●			●	●		●
5,6/400 mm IF-ED		●			●	●		●
4/500 mm IF-ED P		●	●	●	●	●	●	●
4/600 mm IF-ED		●			●	●		●
5,6/600 mm IF-ED		●			●	●		●
5,6/800 mm IF-ED		●			●	●		●
8/800 mm IF-ED					●	●		●
11/1200 mm IF-ED					●	●		●
Mirror lenses								
8/500 mm					②	②		●
11/1000 mm					②	②		●
11/2000 mm					②	②		●
Fisheye lenses								
2,8/6 mm	①	●			●	●		●
2,8/8 mm	①	●			●	●		●
2,8/16 mm	①	●			●	●		●
Special lenses								
PC 3,5/28 mm		③			④	④		●
PC 2,8/35 mm		③			④	④		●
Micro 2,8/55 mm	①	●			●	●		●
Noct 1,2/58 mm	①	●			●	●		●
Micro 2,8/105 mm	①	●			●	●		●
Micro 4/200 mm IF		●			●	●		●
Medical 4/120 mm		●				⑤		●
UV 4,5/105 mm		●			●	●		●
Series E lenses								
2,8/28 mm	①	●			●	●		●
2,8/135 mm	①	●			●	●		●

Key:

AF Autofocus
M/E Manual/electronic focus-assist
P Program mode
S Shutter speed priority
A Aperture priority
M Manual
MM Matrix metering system
MI Centre-weighted integral metering

① with AF Teleconverter TC-16A
② Aperture cannot be preselected
③ unless the PC Nikkor lenses are shifted from the optical axis
④ Exposure is determined by preselection of aperture
⑤ with shutter speed preselection of $\frac{1}{125}$ or longer, flash required.

The Nikon Range of Lenses: The lens table in this book provides an overview of all Nikon lenses suitable for use with the F-801. However, as I have mentioned previously, not all of these lenses are ideal for use with the F-801. At the time of writing, there were only eight AF Zoom lenses, two AF wide-angle, four AF telephoto, two AF standard and one AF macro lenses specifically designed for the F-801. Only the use of these lenses will allow operation of all automatic modes offered by the F-801. Most of the conventional Nikkor lenses will function with the F-801, at least in aperture priority or manual exposure with centre-weighted metering.

The relatively limited offer in AF lenses for the F-801 is a slight disadvantage (a 20mm wide-angle would be no luxury!), but we can hope that Nikon will endeavour to extend their range of lenses in the near future. By the way, we can also look to independent manufacturers to fill the gap.

Useful Accessories

I can't help smiling when I see some so-called photographers laden down by their gadget bags full of "essential" gear and hear them say proudly that they managed to take three shots. On the other hand, one can also make the mistake of not taking enough equipment. The secret lies in finding just the right balance to be ready for any foreseeable situation without overdoing it! But even if one is careful, one always has to take more than one thinks!

Data Backs: There are two types of Data Back available for the F-801; the Data Back MF-20 and the Multi-Control Back MF-21. To be quite honest, to just simply expose the date and time onto the film, I would find the MF-20 too expensive. Firstly, I find this an intrusion on the picture and secondly it seems pointless. However, tastes differ, and so do individual means and requirements. The MF-21, on the other hand, is a different matter; its capabilities are varied:

○ *Interval/timer function:* You can enter starting time, duration

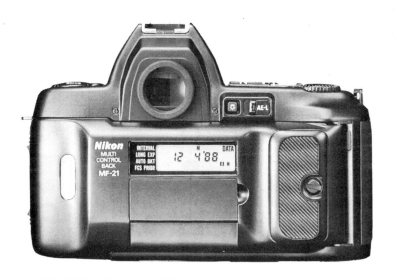

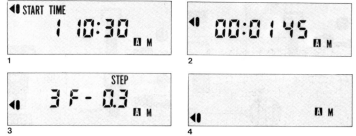

Multi-Control Back MF-21: (1) interval-timer function (2) long exposures (3) automatic exposure sequences (4) autofocus trap

and number of intervals, and number of frames per interval.

○ *Long exposures:* You can enter exposure times from 1 second to 99 hours 59 minutes 59 seconds.

○ *Automatic sequences with exposure bracketing:* You can program a shooting sequence with up to 19 frames, with exposure differences between ⅓ and 2 exposure stops.

○ *Depth-of-field trap:* You focus manually on a certain point and when your subject moves through this focusing plane, the camera will automatically expose.

The above-listed functions can be combined to a certain extent. The automatic exposure sequences are particularly useful, being very handy for testing new films, for example. You can test, say, if you should expose an Ektachrome 100 HC exactly as defined at ISO 100, or at ISO 125 instead. The other functions are more useful for research work in the lab. In such situations one needs exact documentation, and if the automatic function saves sitting up all night, then the investment in the Multi-Control Back MF-21 will not be wasted.

Remote Control: It is not possible to connect a conventional wire release to the F-801. Instead you will have to use an electrical remote cord which connects via the remote control terminal. The Remote Cord with Button Release MC-12A is indispensable for copying, close-ups and also for long exposures, when camera shake is a problem. In most of these situations you could also use the self-timer, but there still is the danger that the carefully-adjusted camera is moved when the release is pressed. There are situations, such as portraits, when the camera is supported on a tripod, and releasing by the remote cord is the better method. You arrange your model, set up the camera, focus and then stand casually next to the camera, trying to put your sitter at ease with light-hearted conversation, your hand on the button release. This method is similar to the one employed with large format cameras.

If you have the Modulite Remote Control Set ML-1 or the Radio Control Unit MW-2, then you can release the F-801 completely independently. This equipment is useful for animal photography in the wild, or also perhaps to catch industrial spys.

Tripods: Essential for available-light photography and for lenses with a focal length of more than 300mm because it is only too easy to move the camera when exposing and even very fast shutter speeds are insufficient to prevent unsharp pictures. I have noticed this when I used my F-801 with a 500mm lens, taking a hand-held shot and another with the camera supported on a tripod, both times at the presumably fast enough shutter speed of $\frac{1}{500}$ sec; the hand-held shot was slightly unsharp.

UV Filter and Lens Hood are Essential: A filter should always be on the lens. Although this means that there are two additional air/glass layers, increasing the danger of flare, the

advantages still outweigh the disadvantages. Both protect the lens against scratches and fingermarks and cut out harmful UV-rays that could cause blur and fogging. Both the UV and the skylight filter absorb UV radiation. The skylight filter also prevents the excessive blue cast which is likely in cloudy conditions, on the beach, in the mountains or if the sun is high in the sky. Personally I find excessive blue more unacceptable than the warmer rendition of colours that the skylight filter gives me but this is a matter of taste.

As mentioned previously, either one of these filters will protect the front element of the lens. It is definitely much cheaper to have to buy a new filter than to have to buy a new lens because it is scratched.

Another essential item to be fitted to all your lenses is a hood to protect against flare. The image on the film should be formed only by the light that stems from the subject. If light enters the lens from the side it could be reflected by the internal surfaces to create flare and cause poor picture contrast and weak colours. If you take a photograph directly into the sun, then a lens hood would be of little use. In practice, lens hoods of hard plastic or metal are better than those made of rubber. The flexible hood can easily get folded back in the heat of the moment and then you find you have some inexplicable vignetting on some of your pictures. Flexible hoods are more practical only when you store your camera.

Polarising Filter for Colour Saturation and Preventing Reflection: This is useful if there are strong reflections from water, windows, gloss paint or plastic surfaces. However, it will not cut out reflections from metal surfaces. In landscape photography the light from the blue sky at right-angles to the sun is polarised strongly. A polarising filter can be used to darken the blue sky in this direction without affecting the reproduction of other colours. They absorb a fair amount of light and you will have to increase the exposure. But this is no problem with the F-801, as the camera will take this into account in all shooting modes. By the way, you will need the more expensive circular polarising filter for the F-801 because the cheaper linear polarising filters are unsuitable. The linear filter could interfere with the AF function and produce incorrect focusing.

173

Caution with Creative Filters: On the matter of these and other attachments, I can only advise you to be cautious. The name alone is wrong! Admittedly, it can happen that a good photograph is even better through the use of a creative filter, but a bad photograph will never become a work of art with the use of such filters. I am not surprised when I find that these filters and attachments do not work as well as I am led to believe (after all, I have had occasion to test over 90 various different types of filters during the course of my professional career). Most of them cannot work as well as the advertisements would have you believe, simply by the laws of optics. Many of these attachments depend on the focal length of the lens, the distance setting, the distance of the filter to the front element, the lighting conditions, etc., etc. One often has to make several exposures with these creative filters and then superimpose them carefully as slides to achieve those picture-book effects.

Another important point to remember when using filters with the F-801 is the possible irritation of the autofocus facility and the exposure metering. It may be necessary to change over to manual focusing and exposure setting and it is better to do the exposure metering before the filter is attached. On the other hand, the use of creative filters opens up a wide field for experimentation and this could provide a lot of fun!

A Good Camera Case is no Luxury: The use of an ever-ready case, which Nikon offers in a great variety is, in my opinion, not exactly suitable for the photographer. As far as I am concerned such cases are, at best, reasonable protection when I store my camera in a rucksack or travel bag. Whenever I wish to take a picture I always find them inconvenient. If you are thinking of accumulating a comprehensive outfit save that money and invest in a really good camera bag. Such a bag should be roomy and offer easy access to the equipment. It should also be light and easy to carry, spray-proof, reasonably dust-proof and it should protect your equipment against knocks. As you see, we are expecting a lot of such a bag and this cannot be fulfilled by any old cheap leather imitation.

Aluminium cases give the best protection but they are heavy and cumbersome. The ideal combination is a good, practical camera bag which accommodates everything that you need to carry with you (films, spare batteries, set of lenses, dusting

brush) plus a transport case for the rest of the equipment. The best way is to keep your camera, without any case, in the camera bag. However, it is important that the various items carried in the bag do not knock against each other (intermediate compartments). Repeated shocks could cause damage.

Camera Body and Lens Back Caps: One item that is essential is the camera body cap. This should always be on the camera when a lens is not attached. Apart from protection against dust, it prevents your touching the mirror by mistake when you take the camera out of the bag. Once is enough to ruin the surface.

The lens back cap is another essential item. This cap should always be put on as soon as the lens is taken from the camera. Not only could you scratch the back element or leave your fingermarks all over it, there is also the danger of bending the aperture lever, etc. These caps usually fit very badly, even if they are the original Nikon caps, being either too loose or hard to fit. Even so, never pull your lens out of the bag by the back cap, unless you want to make some crash tests. You can do without a lens cap for the front lens, provided you always use either a UV or skylight filter.

Service and Care of Your Camera

The care of your F-801 is quite simple. Any excessive cleaning can damage the camera.

Any dust that accumulates in the camera body, for example from the film transport, has to be removed, otherwise it will adhere to the next film. A dusting brush, or better still, a suction brush is suitable for this and also for dusting the front and rear elements of the lenses. Sand is another serious hazard for any camera — if it gets into the shutter mechanism you may as well throw your beautiful F-801 straight into the dustbin so when you take your camera onto the beach or into the desert, keep it in a dust-proof container!

If you get a fingermark on the lens, this should be removed as soon as possible, because perspiration will attack the lens surface and damage it permanently. Scratches or fingermarks are not directly visible on your photographs, but they will cause them to be noticeably flatter, as if a bad soft-focus lens has been

used. To clean lenses and filters use a lens cleaning tissue and lens cleaning liquid which is obtainable specifically for this purpose. Always clean them gently, without exerting any pressure and take care that no dust or hard particles come between the cloth and the lens.

Under no circumstances lubricate your camera or your lenses, not even with the best sewing-machine oil, even if you think something sticks. Even the best oil will become resinous after some time and rather than lubricating the camera, it will cause damage. All cameras and lenses are lubricated when they are assembled, only at those points where it is necessary, which are usually not accessible to you anyway. If you really think your camera makes unusual noises or that the auto diaphragm is sluggish, then you will have to send it to an appointed dealer to have it examined.

If you take your camera into environments with a lot of dust, or very high humidity, then you will have to keep it in an airtight and waterproof plastic case. If it has to be absolutely water-proof, e.g., on a canoe trip, you can get an inflatable bag with float. Don't forget that if your camera is kept in such airtight conditions, condensation can occur and you must not forget to put a bag with drying medium, such as silica gel, into the bag.

In winter, when you bring your camera inside after outside photography, the lens will steam up. The only thing you can do is wipe it down and leave it standing in the open until it has dried; only then should it be stored away. Better still, leave the camera in the camera bag for some hours until it has warmed up.

And now one last bit of advice. If you are not using your camera or your flashgun for some time, remove the batteries. Leaking batteries can damage your camera – and four AAA-size batteries can do a lot of leaking! If you don't use the flashgun for some time you should insert the batteries from time to time. Keep it switched on for a few minutes and then release several times, then re-charge it again and switch it off without discharging it. This procedure will keep the flash capacitor in good condition.

Apart from this you should follow one golden rule. Don't interfere with the camera or the lenses; they don't take kindly to DIY treatment! Always contact your dealer if there are any defects.